IMAGES
of America

FORT PECK

DATE DUE

MAP OF THE STATE OF MONTANA.

IMAGES
of America

FORT PECK
INDIAN RESERVATION
MONTANA

c.2

Kenneth Shields Jr.

ARCADIA
PUBLISHING

Published by Arcadia Publishing
Charleston SC, Chicago IL, Portsmouth NH, San Francisco CA

Printed in the United States of America

Library of Congress Catalog Card Number: 98-88305

For all general information contact Arcadia Publishing at:
Telephone 843-853-2070
Fax 843-853-0044
E-mail sales@arcadiapublishing.com
For customer service and orders:
Toll-Free 1-888-313-2665

Visit us on the Internet at www.arcadiapublishing.com

*This book is dedicated to my beautiful wife, friend, and companion, Judy, who endures
with me and supports me in my many challenges, afflictions, oppressions, and visions.
To my loving and precious children, Toni, Stephanie, Little Kenny, and to my very special
daughter, Tammy, in Browning, Montana, and to my father, Kenneth Sr., my brothers,
Myron and Vernon, in the spirit world. Without them, this work would be meaningless and
insignificant. This is only to say that "Family is Central to Heavenly Father's Plan."*

CONTENTS

Acknowledgments 6

Introduction 7

1. Otuwe (Tribal Village) 9

2. Itancan (Leaders) 23

3. Oyate (People/Nation) 35

4. Odowan and Wowaci (Traditional Song and Dance) 49

5. Wachica Wakpa (Poplar River or Fort Peck Agency) 63

6. Wayawapi (Boarding Schools) 79

7. Wowasi Econ (Working for a Living) 89

8. Aokasin (A Look into their Lives) 101

9. Ikitura (A Delightful People) 115

ACKNOWLEDGMENTS

A very warm and sincere thank you to Ms. Linda Stampoulos for adopting me into her team and believing in me and providing the confidence to move forward to meet the challenge. To Ms. Kirsty Sutton, Arcadia Publishing, a prim and proper British lady, for the courage and foresight it took in trusting me and granting me the privilege of being a component of her enterprise, a gracious thank you. To the noble, kind, and supportive people of the Fort Peck Indian Reservation for entrusting me with their precious photographs and most importantly, their love and inspiration for this work. My dear Mother Serena Good Soldier and Ambrose; my brothers, Darrell, Lester, and Russell; my sisters, Cheryl and Arleda; Mituwe Mercy White Thunder White Bear and Annie; Mituwe Lenora Red Elk; Karen Moe of KUMV-TV Channel 8–Williston, N.D.; to my good friends Chris Traeger, Dwight and Donna Swanson of FPRC-TV Channel 15, Wolf Point, MT; Mr. Larry Youngman, Sherman Crowe family, Laura, Ross, Erica and David Bleazard, Clare Sears, Bonnie Red Elk, Uncle Ervin and Aunt Pearl Four Bear, Cousin Ella Russell and family, Susan Red Boy, Nellie Silk, Mrs. Almira Jackson, Wilma Yellow Robe Williamson, Bonnie LeVay, Kathy Eaton, Larry and Sandra Wolf, Joseph and Caroline Pilgrim, Guy and Dixie Magers, Judy and Carl Walters, Mom and Dad Cutler in Redlands, CA, Ms. Margaret Campbell, Anne Hancock, Minerva Chapman Alberts, Ms. Roxanne Bighorn, Ken and Sylvia Ryan, Shirley Witt, Angela Kirn, Rodney and Ilene Standen, Donna Buckles, Roseline Shields, Marie Cantrell, Darlene and Emory Grey, Wotanin Wowapi, NAES College, Fort Peck Community College, and all my relatives and kodas. To the Montana Historical Society and the Fort Peck Tribal Archives, an acknowledgment for their valuable contribution to the making of this work. For the technical assistance of Jay Arancio of Media Works, my sincere thanks.

INTRODUCTION

In 1851 at Fort Laramie, Wyoming, the tribes of Montana and Dakota Territories signed a treaty with the United States Government. This led to the beginnings of the Fort Peck Indian Reservation and many congressional hearings concerning other reservations. At that time, land consisting of 20 million acres was ceded over to the United States Government and 2 million acres was retained by the Sioux and Assiniboine Tribes of Fort Peck. In 1886 at Fort Peck Agency, once known as Poplar River Agency, the Sioux and Assiniboine exerted their sovereign powers and made agreement with the U.S. Government to create the Fort Peck Indian Reservation. In 1888, the Congress of the United States ratified the agreement and concluded three years of negotiations.

For generations, the Native American people have been a society of great mystery. The Indians of Northeastern Montana are no exception. The idea to reveal some of the nature and character of the Assiniboine and Sioux stemmed from the desire, devotion, and dedication of a certain few individuals to embrace the opportunity to explore this wondrous race of people.

The Agency at Poplar began as a winter camp for Indians in 1845. A French fur trading post was operated by a trapper named Larpentur on Spread Eagle Flat, south of the bluff of Poplar in 1860. The Sioux holyman, Sitting Bull, crossed these plains when leaving the victory of the Little Big Horn in 1876. The small agency also served as a military post. Prior to that, the Pony Express ran through the area in 1867. In 1887, the Great Northern Railroad was completed and first made its run. Camp Poplar was garrisoned until 1893.

After the establishment of the Fort Peck Indian Reservation, there was an outbreak of an unknown illness. Vulnerable to diseases, the Indians suffered many casualties in this region. Official records showed that the Assiniboine and Sioux received blankets infested with small pox. The Indians succumbing to this terrible sickness were buried in common graves. Many burial sites are still being uncovered by work crews today.

This is only a meager part of their tragic history as more affliction and mourning was yet to come. Government agents took it upon themselves to send the Assiniboine and Sioux, with or without permission, to boarding and industrial schools throughout the United States. Family separation and alienation was the final result. This marked the beginnings of a race of people left with near nothing. With their family, language, and culture quickly disappearing, they held on. It was most sad to see them suffer this at the hands of those they entrusted with their care. Later, squalor came, then starvation. More lives were lost. Somehow, though, the Assiniboine and Sioux people managed to live and populate. In humanity, that is a most remarkable feat.

From the combined efforts of their fellows, this precious people will live on through their posterity, and their colorful heritage and legacy is commemorated in this photographic celebration. Taking into account months of research, countless miles traveled, tireless fact finding, endless hours of photo gathering, and letters written and rewritten, the work was finally met with satisfaction. It was, however, not over. Countless mistakes were vindicated for accuracy and all contributed to a rare work seldom seen or read anywhere. In some instances, records of immediate family and relatives could not be found so some Indian people remain unidentified.

Commencing from the 1800s to the near present, the work focuses on the changes that took place among these people in a most grievous time.

Located in northeastern Montana on just over 2 million acres of land, the reservation has oil and gas reserves with some deposits of coal, and rich farmland consisting of wheat, barley, flax, and corn. The reservation has long been a supplier of manpower and was instrumental in the building of the third largest hydraulic/earth-filled reservoir in the world, Fort Peck Dam. This man-made freshwater lake generates enough electric power to serve all of northeastern Montana. The lake itself is a sportsman's paradise with many types of game fish: walleye and northern pike, perch, bass, crappie, and, most recently, sauger salmon.

At times, the weather in this prairie region is harsh and the summers are hot. The reservation, however, thrives with much wild game: quail, pheasant, duck, geese, fox, coyote, bobcat, two types of deer; whitetail, and mule. It also has the largest herds of pronghorn antelope in the world.

Although centuries old, the Indian culture of this region is only now in discovery and exploration. With beautiful handmade arts and crafts made by local talent, the Fort Peck Indian Reservation may soon reach markets in Europe and Asia. There is also a growing interest in traditional song and dance, and this is becoming known worldwide.

It is by these ancient people, their way of life, and their many talents and gifts that prompted the creation of the first Native American title in the *Images of America* series of books. It was through Arcadia Publishing Company, along with the tireless efforts of Pompano Associates, that this great opportunity took form. It is through the allegiance and commitment of these entities that the author is fortunate to envision the beginning of a work for ancestry reborn. Now, people nationally and internationally may have a first-hand account and understanding of this Indian people manifested by way of a photographic celebration.

This is only a fraction of the mystery of the American Indian's way of life. These wonderful, spiritual people extend an invitation and a warm welcome to all visitors. There will be no disappointment in meeting a delightful people. This cultural exchange is sure to change you.

Pidamaya, hecetu.

The Author

One

OTUWE
(TRIBAL VILLAGE)

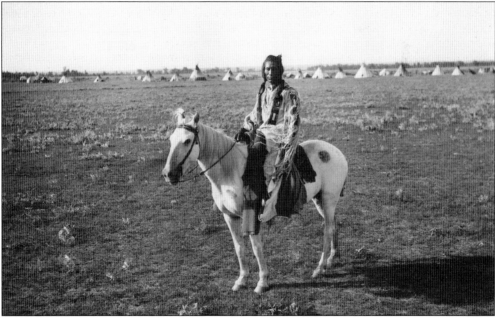

THE OTUWE OR VILLAGE, DWELLING PLACE OF THE PEOPLE, C. 1880. According to tribal custom, it takes a whole village to properly raise a child. When the child is nurtured in this way, he or she will become an Itancan or leader for the Oyate. The Oyate or people or nation, honor the Itancan in a most spiritual way by Odawan and Wowaci, song and dance, now known as powwows. An unknown sentry stands guard at the boundary to a camp. Warriors rode ponies that were hardy and swift runners. Most rode bareback, but this one uses a saddle, probably a McClellan obtained from a trading post. Encampments such as this were situated in a circle with each individual family in their own designated area. (Photograph courtesy of Fort Peck Tribal Archives.)

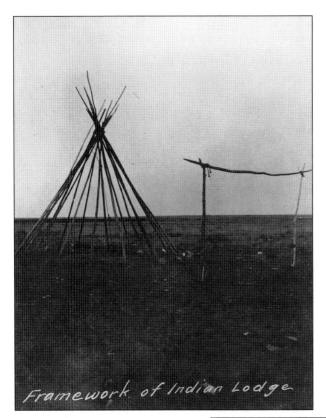

Framework of Indian Lodge

FRAMEWORK OF AN INDIAN LODGE, LATE 1800S. Indians traveled many miles to cut, dry, and cure lodge poles. Only certain times of the year is this done. The framework must be laid and tied in a certain way to ensure insure stability to withstand the most harsh weather conditions. Nearby is a rack for drying meat and other food staples. (Photograph courtesy of Fort Peck Tribal Archives.)

HOME OF SIOUX INDIAN FAMILY, LATE 1800S. Family was essential to the Native Americans. Lodges were covered with buffalo hide to keep them warm. Once tanned, it was strong and could withstand certain weapon projectiles. This lodge, which is receiving visitors, is located at North Poplar Agency. Wagons were important tools in doing chores and receiving the gratuities from the government. (Photograph courtesy of Fort Peck Tribal Archives.)

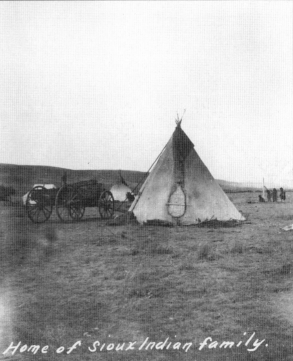

Home of Sioux Indian family.

SIOUX INDIAN LODGE, C. 1905.
Although there were many bands
of Sioux, the tribe pictured here
may be Yankton Sioux. Two
wagons appear in the foreground,
while a log house is visible in the
background. Caucasian influence
was already taking shape in this
area. Note the canvas covering
on the wagon in the foreground.
(Photograph courtesy of Fort Peck
Tribal Archives.)

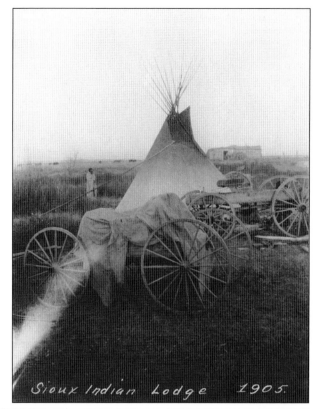

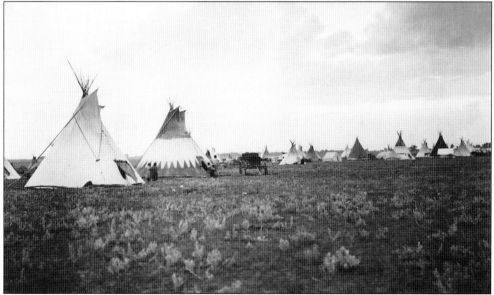

DAKOTA HOMES ON THE PRAIRIE, C. 1880. What was once buffalo hide for lodges became commercial canvas and paint as Caucasian influence spread. On the tepee's, note the different designs depicted. These were tied to spiritual and family beliefs. Lodges were always placed according to family. Note the walltents acquired from military surplus in front of the lodges. (Photograph courtesy of Fort Peck Tribal Archives.)

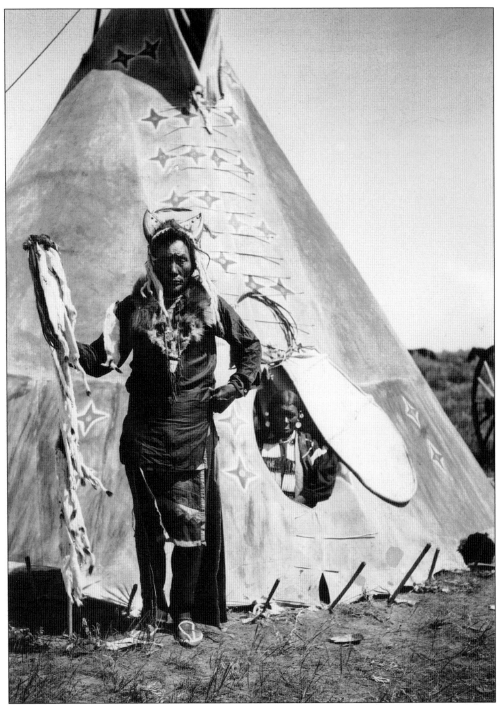

A Devout Religious Man, late 1800. Although pious, these men occasionally allowed themselves to be photographed. Staffs were important and a mark of leadership. Headdresses, also quite consequential, were an indication of bravery and heroism on the battlefield. The woman behind the man is adorned in a bone breastplate. (Photograph courtesy of Fort Peck Tribal Archives.)

PLENTY ARROWS SIOUX INDIAN, c. 1880. Many Indians adapted the hat as part of their personal décor. Note the silver conches making up a belt. Although Caucasian influence was becoming widespread, Indians still retained their traditional adornment. (Photograph courtesy of Fort Peck Tribal Archives.)

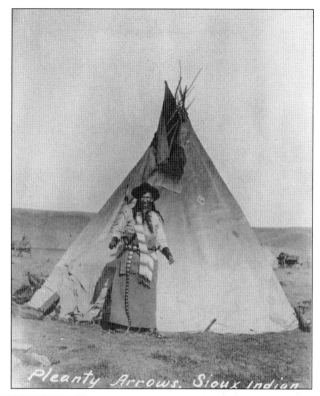

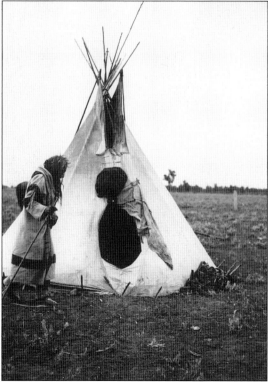

INDIAN RETURNING TO HIS LODGE, c. 1880. Visiting others was always encouraged and became a part of daily life for the Plains Indian. Lodges were always situated so that they faced an easterly direction. (Photograph courtesy of Fort Peck Tribal Archives.)

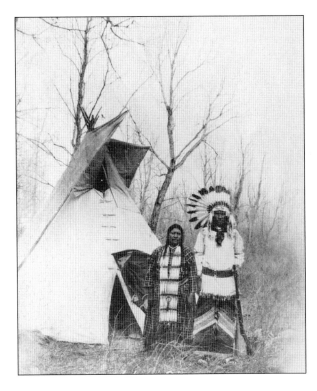

YANKTON SIOUX INDIANS AT POPLAR RIVER AGENCY, LATER CALLED FORT PECK, C. 1880. The people portrayed here are identified as Horses Ghost and his wife. He is armed with a Winchester rifle, an important instrument as a provider for the family. Trading for firearms with the whiteman, however, was not always encouraged by the government. (Photograph courtesy of Fort Peck Tribal Archives.)

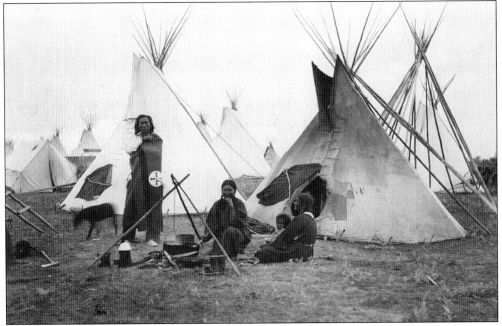

FAMILY PREPARING A MEAL, C. 1880. The patriarch stands while the family continues to eat like nothing is out of the ordinary. The young woman pictured on the right holds her child. (Photograph courtesy of Fort Peck Tribal Archives.)

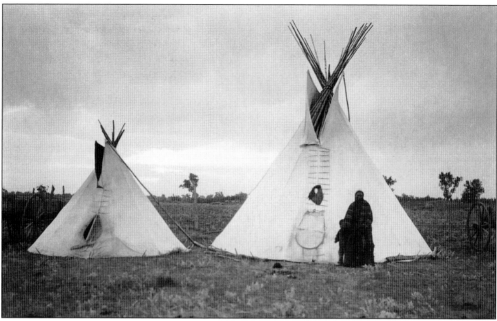

SIOUX CAMP. The whereabouts of this camp are unknown. (Photograph courtesy of Fort Peck Tribal Archives.)

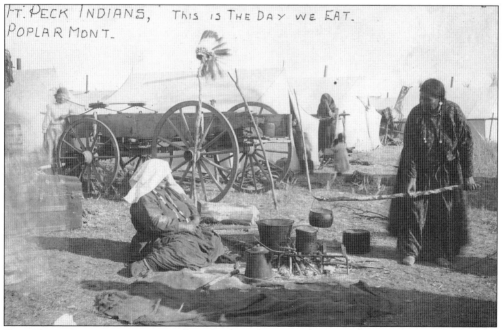

FORT PECK INDIANS, C. 1880. This photograph is entitled, "This is the day we eat. Poplar, Montana." Women were sometimes shy and hid their faces—notice the two ladies hiding. Cooking and eating were always of importance to the Indians and visitors were always welcome. Note the cast iron cooking utensils. (Photograph courtesy of Fort Peck Tribal Archives.)

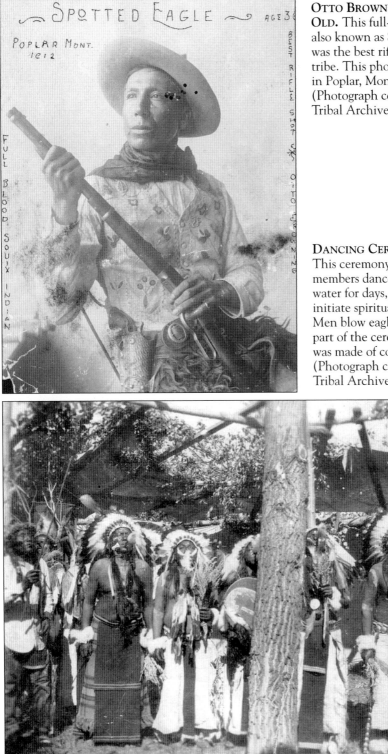

In the photograph, handwritten text reads:

SPOTTED EAGLE AGE 36
POPLAR MONT. 1912
FULL BLOOD SOUIX INDIAN
BEST RIFLE SHOT — OTTO BROWNING

OTTO BROWNING, 36 YEARS OLD. This full-blood Sioux was also known as Spotted Eagle. He was the best rifle shooter in the tribe. This photograph was taken in Poplar, Montana in 1912. (Photograph courtesy of Fort Peck Tribal Archives.)

DANCING CEREMONIAL, C. 1880. This ceremony, where the tribal members danced without food or water for days, was intended to initiate spiritual enlightenment. Men blow eagle bone whistles as part of the ceremony. The shade was made of cottonwood branches. (Photograph courtesy of Fort Peck Tribal Archives.)

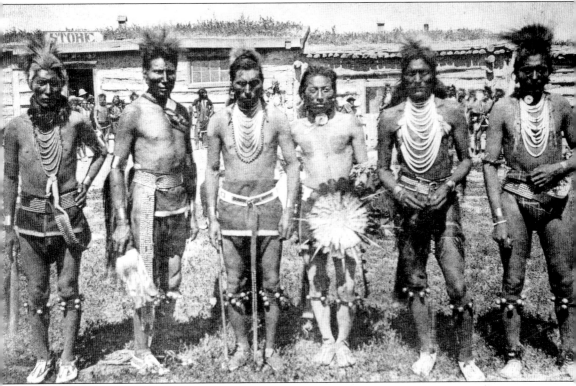

UNIDENTIFIED INDIANS GATHERED OUTSIDE A LOG CABIN, LATE 1800. It is interesting to see the weeds growing on top of house. Sod was used in building these structures. (Photograph courtesy of Fort Peck Tribal Archives.)

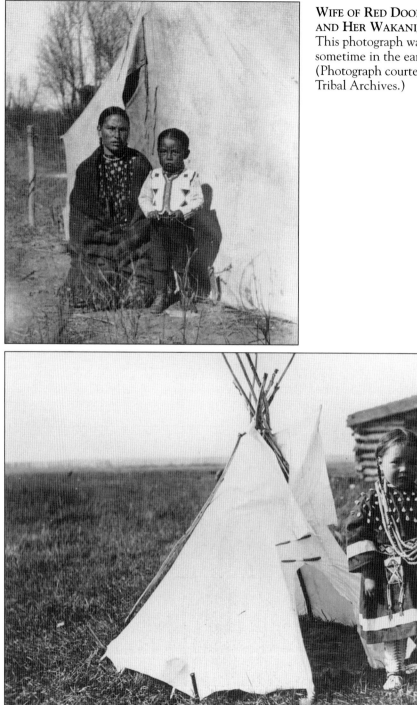

WIFE OF RED DOOR (SIOUX) AND HER WAKANIJA (CHILD). This photograph was taken sometime in the early 1900s. (Photograph courtesy of Fort Peck Tribal Archives.)

UNIDENTIFIED INDIAN GIRL WITH HER "PLAY TEPEE," EARLY 1900S. Children were precious, and making things to play with made them feel grown up. This child is adorned in a dancing costume consisting of seashells and beads. A log home is visible in the background. (Photograph courtesy of Fort Peck Tribal Archives.)

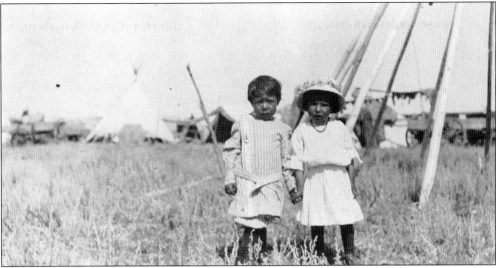

UNIDENTIFIED CHILDREN HOLDING HANDS, C. 1900. Obviously, there was some non-Indian influence in their dress. (Photograph courtesy of Fort Peck Tribal Archives.)

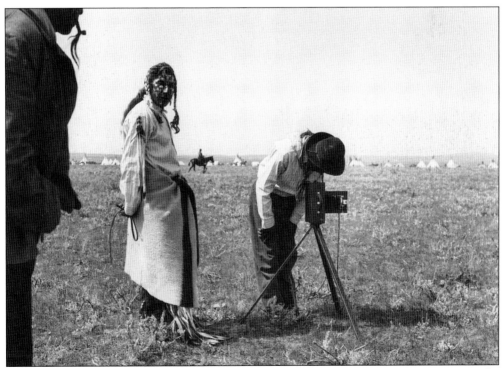

PHOTOGRAPHER TAKING PICTURES WHILE CURIOUS INDIAN WATCHES, LATE 1800S. The Indians believed that these contraptions captured the soul of a person. The men in the photo are unknown. (Photograph courtesy of Montana Historical Society.)

SIOUX INDIAN CHILDREN, MAE LESTER AND LAWRENCE FAST HORSE, C. 1920. Presumably, these children are pictured at the Fort Peck agency building. (Photograph courtesy of Fort Peck Tribal Archives.)

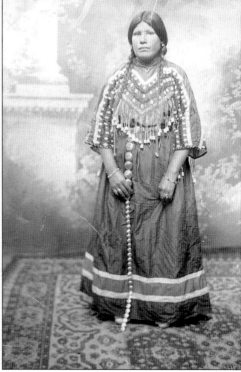

STUDIO PORTRAIT OF MAGGIE IRON CLOUD RED ELK, EARLY 1900S. While attending government schools, many Indian people posed for such photos. (Photograph courtesy of Fort Peck Tribal Archives.)

INDIAN FAMILY PORTRAIT, EARLY 1900S. (Photograph courtesy of Fort Peck Tribal Archives.)

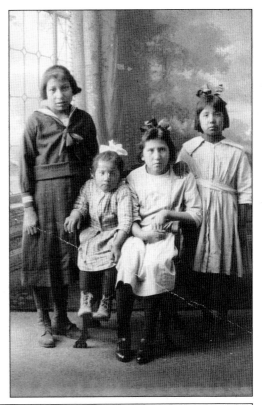

INDIAN FAMILY OUTSIDE THEIR LOG HOME, EARLY 1900S. The man dressed in a suit could be a minister. Catholic and Presbyterian influence was strong on the reservation. (Photograph courtesy of Fort Peck Tribal Archives.)

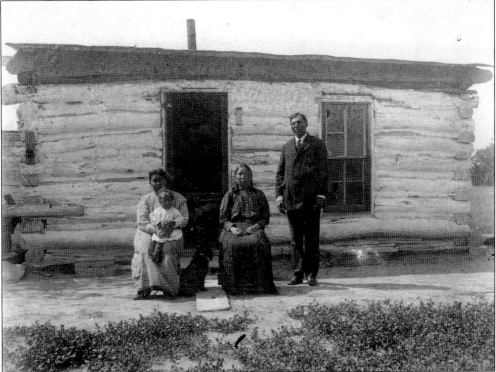

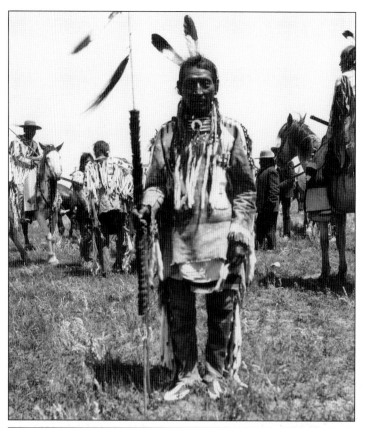

INDIAN LEADER HOLDING A STAFF, EARLY 1900S. These men were very critical and highly respected among the Indian people. This man appears to be in meeting with Indian agents. (Photograph courtesy of Fort Peck Tribal Archives.)

INDIAN IN FULL GARB MOUNTED ON HIS HORSE, C. 1880. Note the rawhide shield complete with eagle feathers. This was useful in close quarter fighting to guard against clubs, knives, etc. (Photograph courtesy of Fort Peck Tribal Archives.)

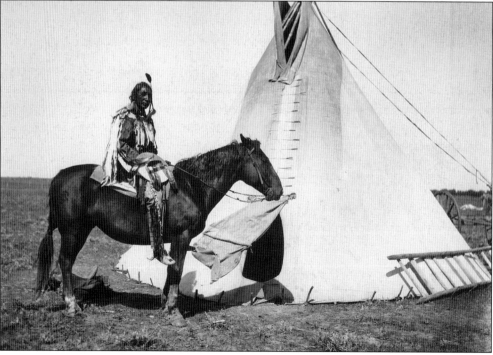

Two

ITANCAN

(LEADERS)

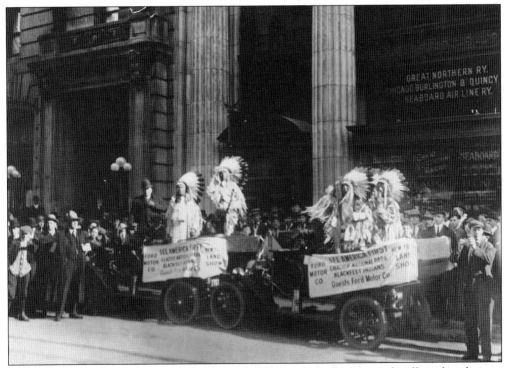

SIOUX LEADERS, NOVEMBER 1911. These men accompanied Major Lohmiller when he was called to confer in Washington, D.C., with officials of the Taft Administration. Pictured left to right are as follows: Spotted Eagle, Iron Whip, Horses Ghost, Grow Twice, and Kill Twice. Note the Ford Motor Company banners. (Photograph courtesy of Montana Historical Society.)

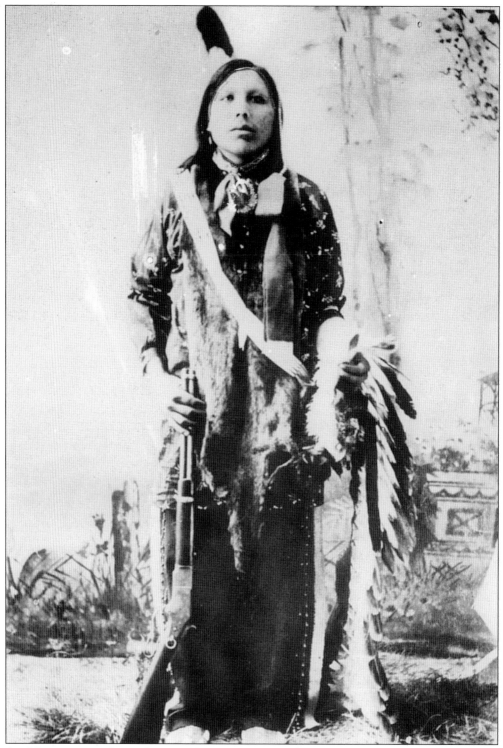

An Unidentified Sioux Indian, Early 1900s. Holding a Winchester rifle, this man posed at a studio. (Photograph courtesy of Montana Historical Society.)

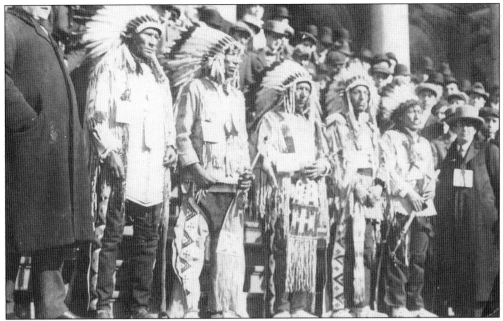

SIOUX DELEGATION IN WASHINGTON, 1911. Spotted Eagle, Iron Whip, Horses Ghost, Grow Twice, and Kill Twice appear here outside the Capitol Building while on their trip accompanying Major Lohmiller. (Photograph courtesy of Montana Historical Society.)

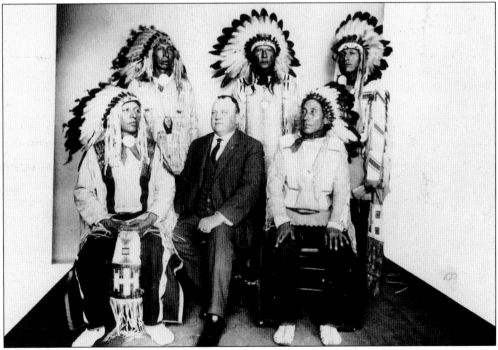

SAME SIOUX DELEGATION IN A PORTRAIT WITH MAJOR LOHMILLER, 1911. Pictured from left to right are as follows: Iron Whip, Spotted Eagle, Horses Ghost, Grow Twice, and Kill Twice. Lohmiller was also superintendent of Fort Peck Agency. (Photograph courtesy of Montana Historical Society.)

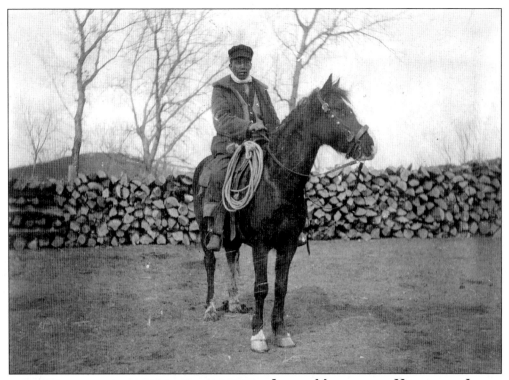

INDIAN MOUNTED ON HORSEBACK, LATE 1900S. On their horses, Indians of the reservation made good cowhands. Note rope around the saddle horn. (Photograph courtesy of Fort Peck Tribal Archives.)

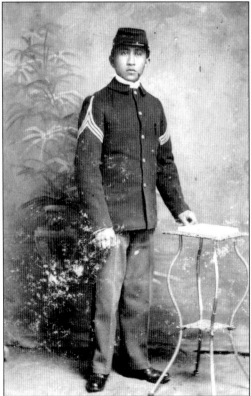

SERGEANT WARREN CARL, LATE 1900S. Indians at Fort Peck made model soldiers; because of their bravery, they were held in high esteem. (Photograph courtesy of Fort Peck Tribal Archives.)

GEORGE FAST HORSE. A spiritual man, his gifts were much sought after by the Indian people. Indians of Canada also knew of him, and traveled far for administrations. (Photograph courtesy of Montana Historical Society.)

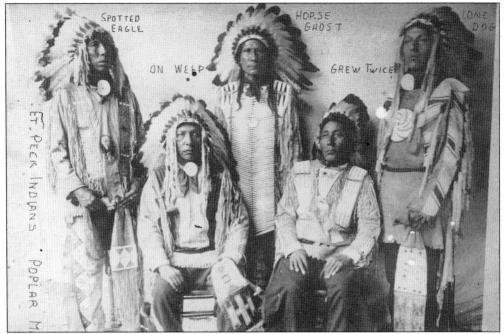

FIVE SIOUX LEADERS, C. 1911. Men pictured are identified from left to right as follows: (front row) Iron Whip and Kill Twice; (back row) Spotted Eagle, On Weep, and Grew Twice. (Photograph courtesy of Montana Historical Society.)

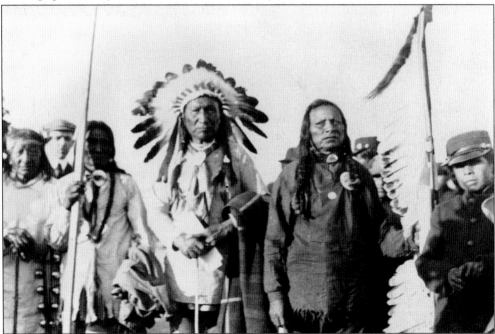

UNIDENTIFIED INDIANS PARTICIPATING IN THE FESTIVITIES AT THE INDIAN FAIR, JULY 17, 1913. This fair was held in Poplar, Montana, to celebrate the arrival of the Glidden Tours and the special Great Northern train. Note the Indian boy wearing a band uniform from the government school. (Photograph courtesy of Montana Historical Society.)

FORT PECK INDIAN LEADERS, SPOTTED EAGLE AND GREW TWICE, C. 1911. These men were from Poplar, Montana. (Photograph courtesy of Fort Peck Tribal Archives.)

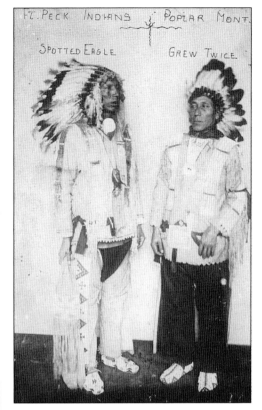

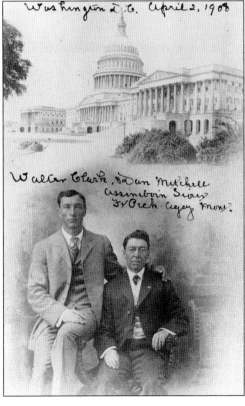

WALTER CLARK AND DAN MITCHELL, ASSINIBOINE/SIOUX. They are pictured here while in Washington, D.C., during April 1908. (Photograph courtesy of Montana Historical Society.)

29

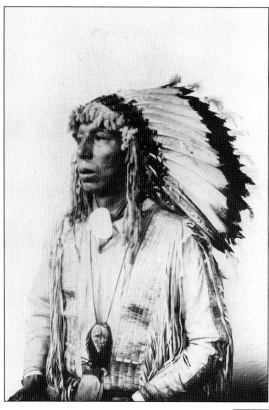

SPOTTED EAGLE, C. 1911. Spotted Eagle was one of the Sioux leaders who accompanied Major Lohmiller to Washington, D.C., during the Taft Administration. (Photograph courtesy of Montana Historical Society.)

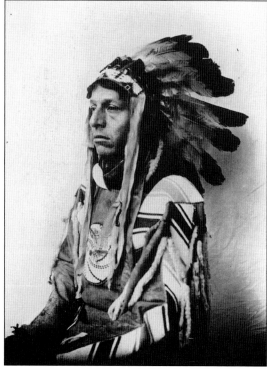

KILL TWICE, C. 1911. Kill Twice was also one of the Sioux leaders who accompanied Major Lohmiller to Washington, D.C., during the Taft Administration. (Photograph courtesy of Montana Historical Society.)

GREW TWICE, C. 1911. Grew Twice was one of the Sioux leaders who accompanied Major Lohmiller to Washington, D.C., during the Taft Administration. (Photograph courtesy of Montana Historical Society.)

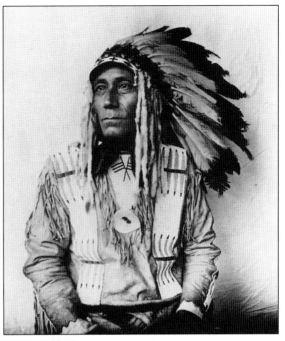

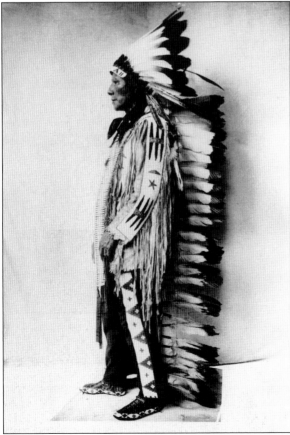

HORSES GHOST, C. 1911. Horses Ghost was another one of the Sioux leaders who accompanied Major Lohmiller to Washington, D.C., during the Taft Administration. (Photograph courtesy of Montana Historical Society.)

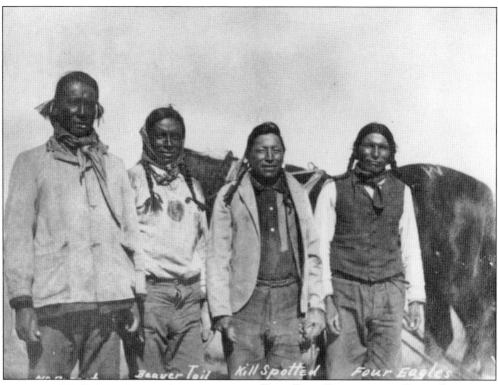

FORT PECK RESERVATION SIOUX INDIANS. Pictured from left to right are as follows: No Breast, Beaver Tail, Kill Spotted, and Four Eagles. (Photograph courtesy of Fort Peck Tribal Archives.)

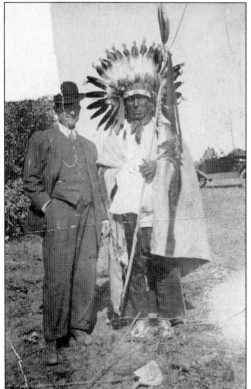

JOSEPH RED ELK, A SIOUX, AND AN UNIDENTIFIED MAN, C. 1914. (Photograph courtesy of Montana Historical Society.)

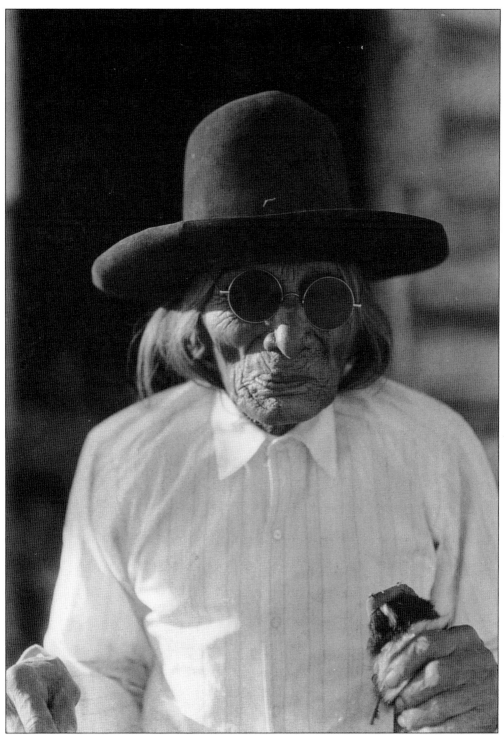

Paguta Sapa, or Black Duck, at Fort Peck Indian Agency. He was an important man in the district of Riverside, also known as Maka Icu-Takes Earth. Black Duck has many surviving descendants. (Photograph courtesy of Montana Historical Society.)

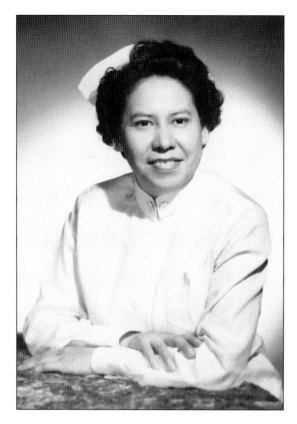

MRS. ANNE HANCOCK-ASSINIBOINE.
She completed her nurses training in
Philadelphia, Pennsylvania. A real
leader and role model for her Indian
people, Mrs. Hancock contributed
many dedicated years in service to
them. (Photograph courtesy of
Anne Hancock.)

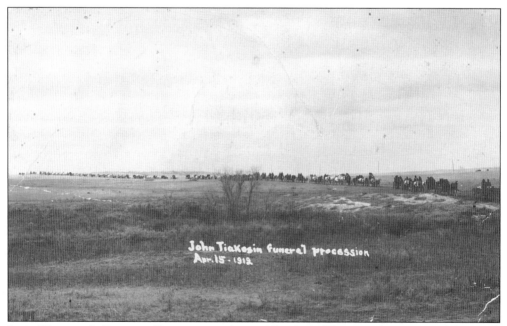

JOHN TIAKESIN'S FUNERAL PROCESSION, APRIL 15, 1912. (Photograph courtesy of Fort Peck
Tribal Archives.)

Three

OYATE

(PEOPLE/NATION)

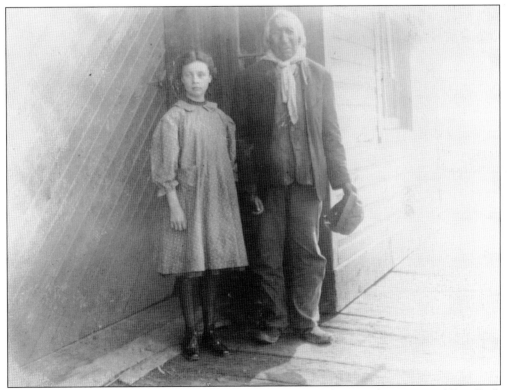

MINNIE SMITH AND UNCLE DEER TAIL, C. MAY 1907. (Photograph courtesy of Fort Peck Tribal Archives.)

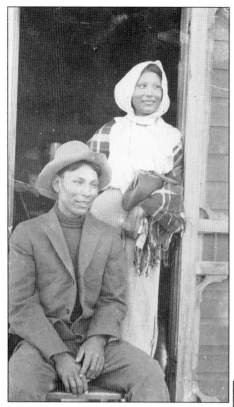

UNIDENTIFIED INDIAN COUPLE AT FORT PECK. (Photograph courtesy of Fort Peck Tribal Archives.)

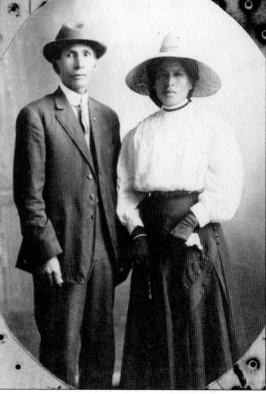

NEATLY-DRESSED UNIDENTIFIED INDIAN COUPLE. (Photograph courtesy of Fort Peck Tribal Archives.)

Two Unidentified Indian Ladies, Possibly Mother and Daughter.
Their colorful dresses were made of satin, and their breastplates were made of eagle bone or the bone of another similar bird. (Photograph courtesy of Fort Peck Tribal Archives.)

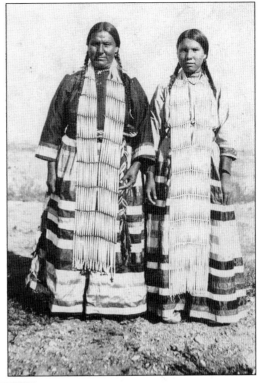

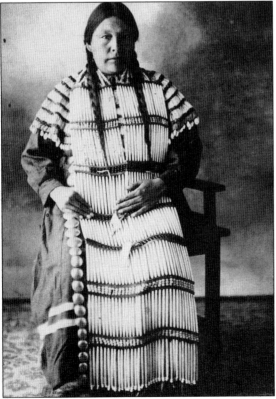

Unidentified Indian Lady in Complete Raiment. (Photograph courtesy of Fort Peck Tribal Archives.)

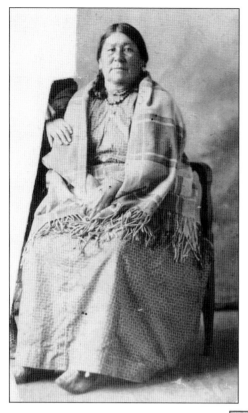

UNIDENTIFIED ELDERLY INDIAN LADY. By all means, this woman is an "uci" or grandmother. (Photograph courtesy of Fort Peck Tribal Archives.)

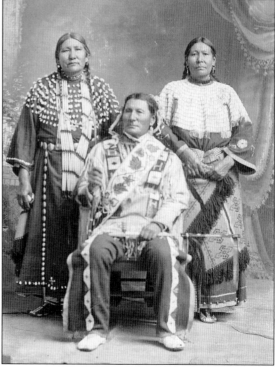

UNIDENTIFIED INDIANS. Holding a pipe or canupa, the man appearing in front with the sash must have had a leadership position. The women in back could have been his wives. Plural marriages were not uncommon in some tribes. (Photograph courtesy of Fort Peck Tribal Archives.)

UNIDENTIFIED WOMAN WITH CHILD.
Children were highly regarded and cared for by the tribal members. They were carried in a cradle board, which gave them very strong backs and caused babies to stand at an early age. (Photograph courtesy of Fort Peck Tribal Archives.)

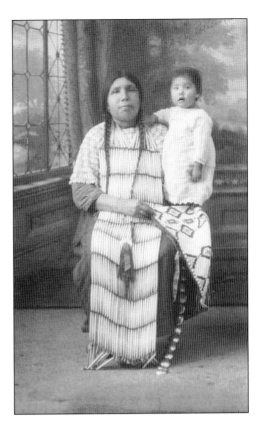

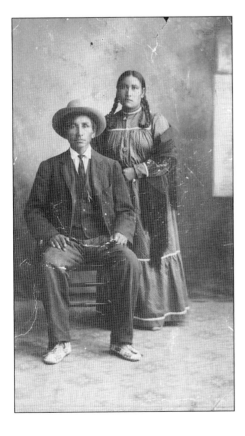

UNIDENTIFIED COUPLE. Finding the white man's clothes pleasing, many Indians acquired them. (Photograph courtesy of Fort Peck Tribal Archives.)

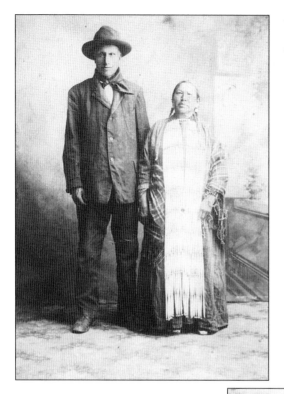

UNIDENTIFIED INDIAN COUPLE.
(Photograph courtesy of Fort Peck
Tribal Archives.)

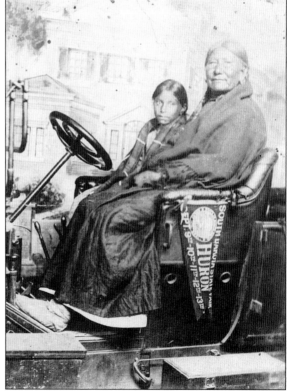

**BLACK BEAR IN THE DRIVER'S SEAT
OF A MODEL T, C. 1900.** Susan
Red Boy's Grandmother, Yellow
Back, is the little girl. The Indian
people enjoyed automobiles and
took every opportunity to sit in one.
(Photograph courtesy of Susan
Red Boy.)

40

UNIDENTIFIED INDIAN CHILDREN, POSSIBLY SISTERS. In preparation for motherhood, girls always took care of the younger ones. (Photograph courtesy of Fort Peck Tribal Archives.)

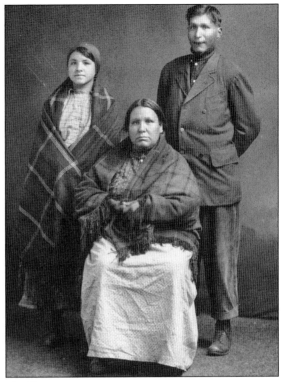

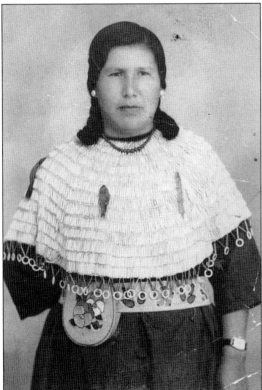

UNIDENTIFIED INDIAN LADY. Note the wristwatch above her right hand. The white intricate work is porcupine quill. (Photograph courtesy of Fort Peck Tribal Archives.)

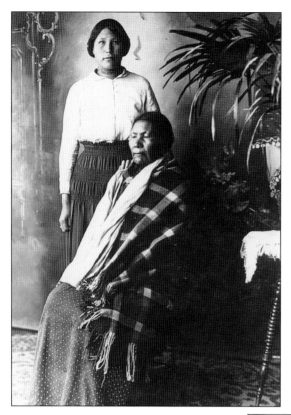

THELMA RED EAGLE, STANDING, AND AN UNIDENTIFIED WOMAN. (Photograph courtesy of Fort Peck Tribal Archives.)

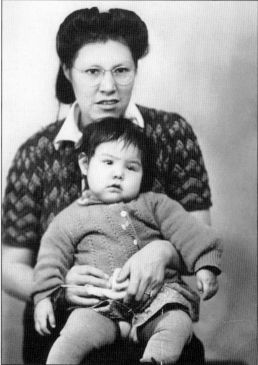

INDIAN MOTHER AND CHILD. (Photograph courtesy of Fort Peck Tribal Archives.)

ANNIE GOOD (LEFT) AND THELMA RED EAGLE, NOVEMBER 15, 1915. This photograph was taken at Wolf Point, Montana. (Photograph courtesy of Fort Peck Tribal Archives.)

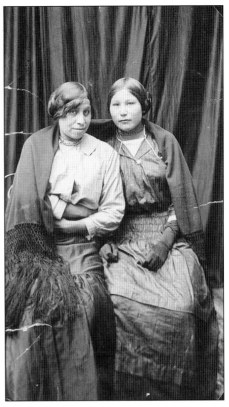

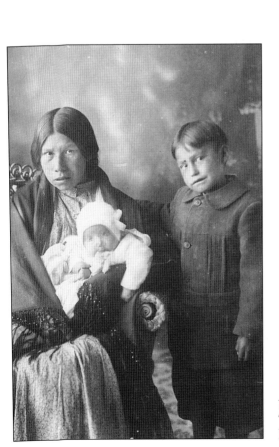

UNIDENTIFIED INDIAN MOTHER AND HER TWO CHILDREN. (Photograph courtesy of Fort Peck Tribal Archives.)

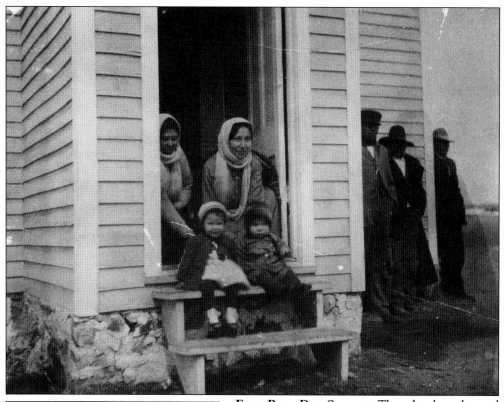

FORT PECK DAY SCHOOL. The school was located in Riverside, Montana. (Photograph courtesy of Fort Peck Tribal Archives.)

PROCTOR HOUSE, BUILT ON THE FORT PECK INDIAN RESERVATION, NORTH OF POPLAR. (Photograph courtesy of Laura Bleazard.)

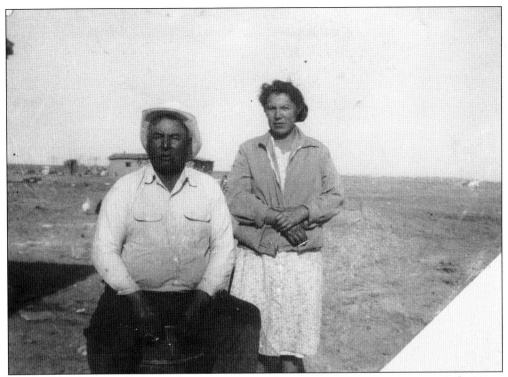

LUMYNA CLOKE, SIOUX INDIAN, AND ADOPTED FATHER, HOWARD IRON LEGGINGS. This photograph was taken west of Poplar. (Photograph courtesy of Ella Russell.)

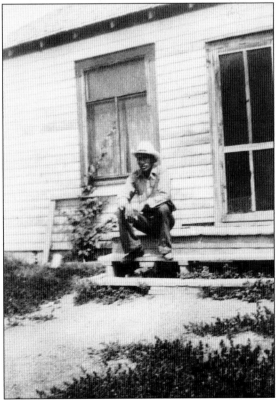

TOM RYAN JR., OF THE ASSINIBOINE TRIBE. (Photograph courtesy of Fort Peck Tribal Archives.)

THEODORE "TED" CROWE. A Sioux Indian, he was a very tall man. He was married to Sarah Lester and all of their three sons fought in wars. She became a Gold Star Mother in recognition of their feats. (Photograph courtesy of Sherman Crowe.)

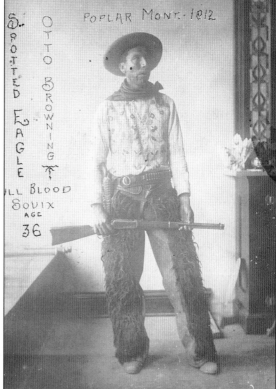

SPOTTED EAGLE OR OTTO BROWNING, A FULL-BLOOD SIOUX INDIAN. This photograph was taken in Poplar, Montana, in 1912. (Photograph Courtesy of Fort Peck Tribal Archives.)

A SIOUX DESCENDANT OF FEATHER EARRING, C. 1900. Feather Earring was at the Battle of the Little Bighorn in 1876. This photo was taken at a rendezvous in an unknown location. (Photograph courtesy of Judy Shields.)

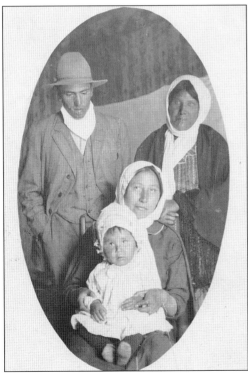

SIOUX INDIANS EDDY BEAR AND FAMILY, C. 1900. His wife was Constance Beaver Tail, Bear. (Photograph courtesy of Fort Peck Tribal Archives.)

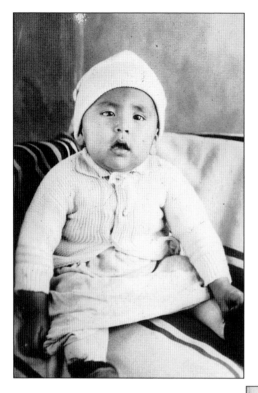

PETE MATTHEWS JR., BORN NOVEMBER 22, 1919. (Photograph courtesy of Darlene Grey.)

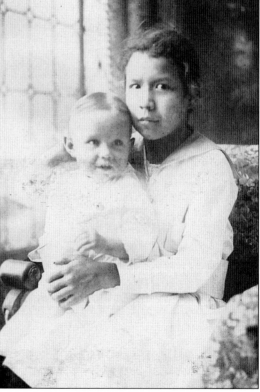

TWO UNIDENTIFIED INDIAN CHILDREN. (Photograph Courtesy of Fort Peck Tribal Archives.)

Four

ODOWAN AND WOWACI
(TRADITIONAL SONG AND DANCE)

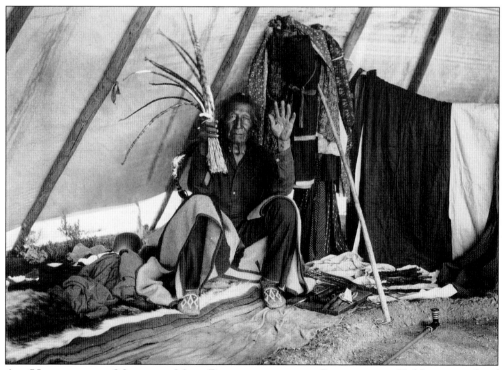

AN UNIDENTIFIED MEDICINE MAN PREPARING FOR A CEREMONIAL. Holding strands of sweetgrass in his hands, he hopes that these pleasant-smelling plants bring a spiritual atmosphere to their rituals. The lodge is the sacred home of the medicine man or wicasa wakan. (Photograph courtesy of Fort Peck Tribal Archives.)

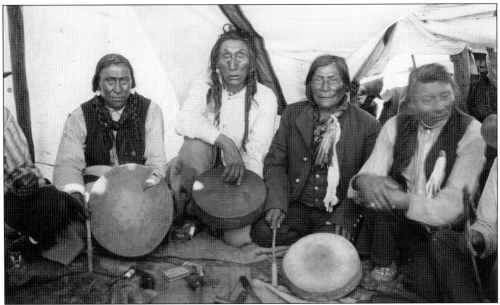

MEN IN PREPARATION FOR A CEREMONY, EARLY 1900. Each man has a drum for individual songs and will play his own part in the ceremony. The pipes placed in the front of them will also be an important element. (Photograph courtesy of Fort Peck Tribal Archives.)

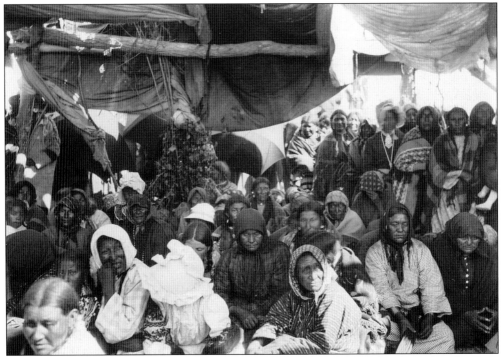

INDIAN LADIES WAITING FOR THE CEREMONY TO BEGIN, EARLY 1900S. Women have an important part in supporting the men. In addition, they are considered to be most sacred at certain times of the month when they have their cycle. (Photograph courtesy of Fort Peck Tribal Archives.)

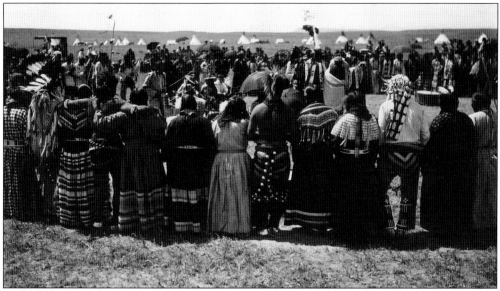

A Ceremonial Taking Place Out on the Prairie, Early 1900s. The Indian felt right at home in this place where he could feel a closeness to Mother Earth. Therefore, some ceremonies occurred out here. (Photograph courtesy of Fort Peck Tribal Archives.)

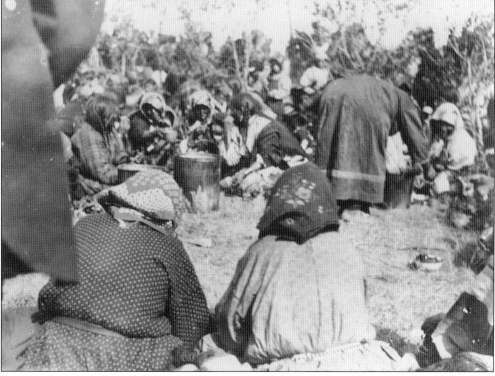

Indian Ceremony, Early 1900s. During ceremonies, a feast is always presented. The large metal containers were used for cooking meat. Everyone gathered into a circle and shared the meal. It was a time for renewing old friendships and making new ones. (Photograph courtesy of Fort Peck Tribal Archives.)

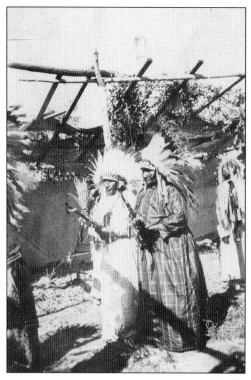

SIOUX INDIAN LADIES, EARLY 1900S. This pipe ceremony was held in their honor. Wearing war bonnets, these women could easily be war mothers whose sons served. Men sing the song while the women dance in a circle. A shield hangs in the background. (Photograph courtesy of Fort Peck Tribal Archives.)

CEREMONY HELD TO HONOR TWO SIOUX WOMEN, EARLY 1900S. Ceremonies were important and the Indian people performed these rites in respect to people they honored. The war bonnets are an important part in the ceremonies. The women honored here must have performed feats or certain duties for the people. (Photograph courtesy of Montana Historical Society.)

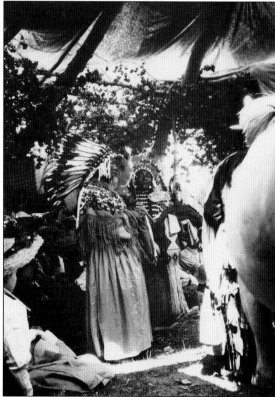

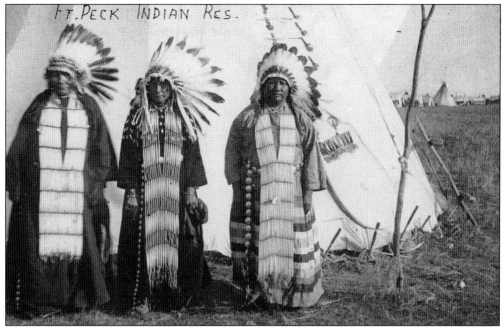

SIOUX INDIAN WOMEN WEARING WAR BONNETS, 1900S. War mothers were given the titles to honor sons killed in war. Today these very same war mothers are honored in the same way. (Photograph courtesy of Montana Historical Society.)

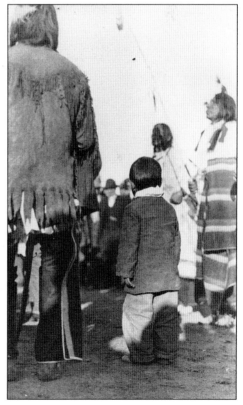

POPLAR INDIAN FAIR, JULY 17, 1913. A little Sioux Indian boy watches the festivities at the fair held to celebrate the arrival of the Glidden Tours. From a tender age, they are taught tradition and become learned in its ways. The man next to him must be his father. (Photograph courtesy of Montana Historical Society.)

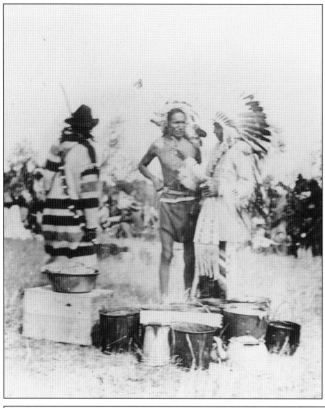

SIOUX INDIANS PREPARING FOR THE "SUN DANCE" AND CEREMONIES, LATE 1880s. This photograph was taken on the Fort Peck Indian Reservation in Poplar, Montana. (Photograph courtesy of Montana Historical Society.)

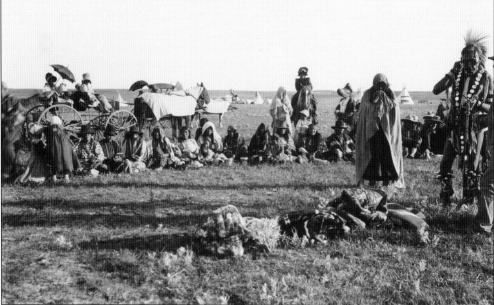

A "GIVEAWAY" IN HONOR OF A DECEASED LOVED ONE, LATE 1900s. For the plains Indian, this is a time for mourning and honoring a loved one who has passed on. Everyone who contributes to their comfort is given a gift in thankfulness. (Photograph courtesy of Fort Peck Tribal Archives.)

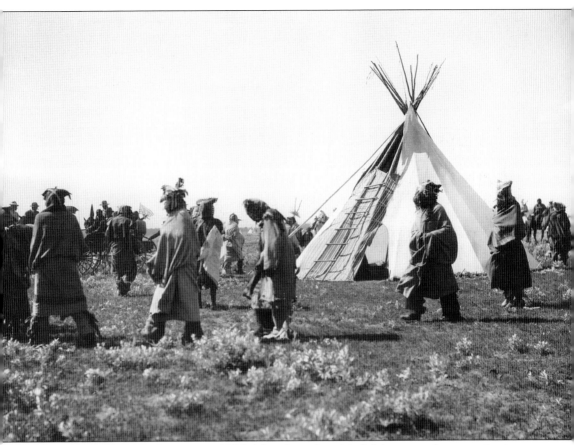

"Heyoka" or Indian Clown, c. 1880. Men dressed in this fashion to perform certain rites. It is believed by the Indian people that they possess certain powers. (Photograph courtesy of Fort Peck Tribal Archives.)

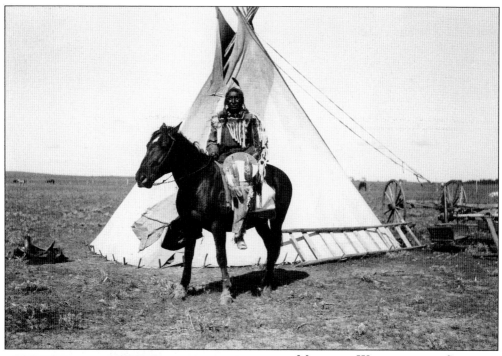

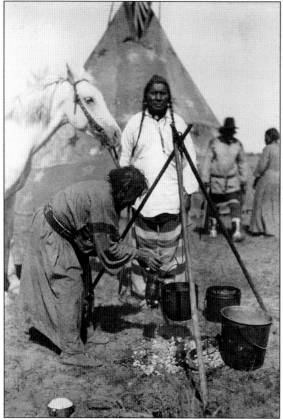

MOUNTED WARRIOR WITH SHIELD, C. 1880. Esteemed for their courage, these men were protectors and providers for the camp. The trappings are evidence of his standing as a warrior. (Photograph courtesy of Fort Peck Tribal Archives.)

SPECIAL CEREMONIAL MEAL, EARLY 1900S. Food is an important part in ceremonies. Notice the metal cauldrons used for cooking. (Photograph courtesy of Fort Peck Tribal Archives.)

Lodge with Symbols Representing the Thunderbird, c. 1900. The Thunderbird was an entity representing the thunder in the skies. Lodges like the one pictured here were used for certain ceremonies. (Photograph courtesy of Fort Peck Tribal Archives.)

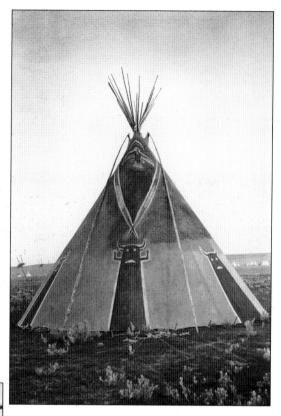

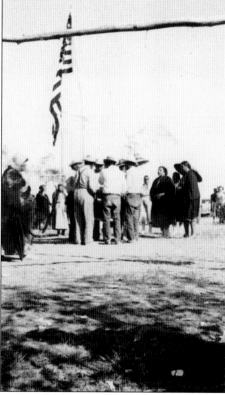

Sioux Indians Gathering Around to Sing, Late 1900s. Honor songs begin the festivities. Women joined in with their high-pitched voices, bringing much beauty to the song. The American flag, also visible here, is deeply respected by the Indian. (Photograph courtesy of Fort Peck Tribal Archives.)

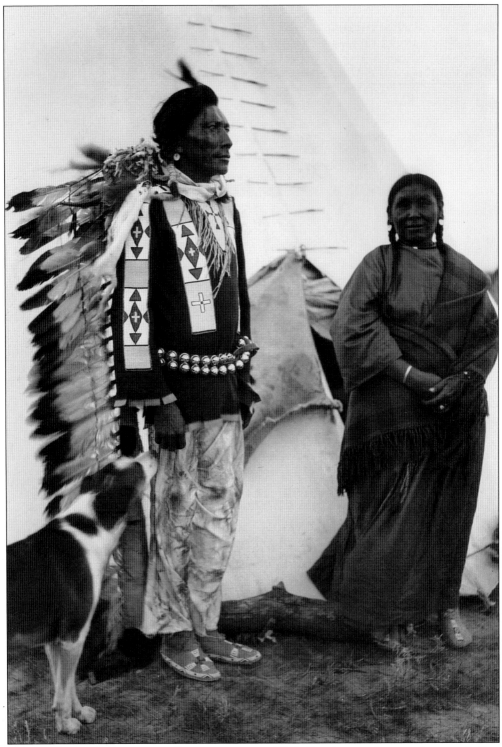

INDIAN COUPLE POSING FOR A PHOTOGRAPH, C. 1900. Rarely can photographers get Indian people to pose for them. (Photograph courtesy of Fort Peck Tribal Archives.)

UNIDENTIFIED INDIAN MAN AND HORSE, LATE 1900S. The horse he is holding will be given away later. Giving horses is a great honor to both the giver and receiver. (Photograph courtesy of Fort Peck Tribal Archives.)

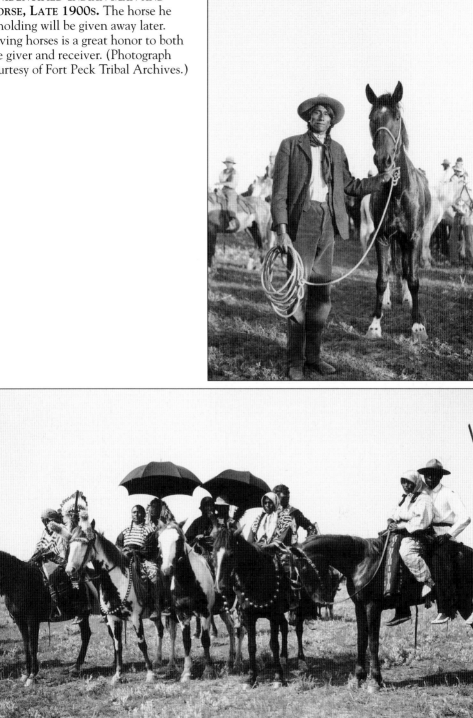

INDIANS GOING TO A CELEBRATION, C. 1900. Umbrellas were very much sought after and it was commendable to have one. (Photograph courtesy of Fort Peck Tribal Archives.)

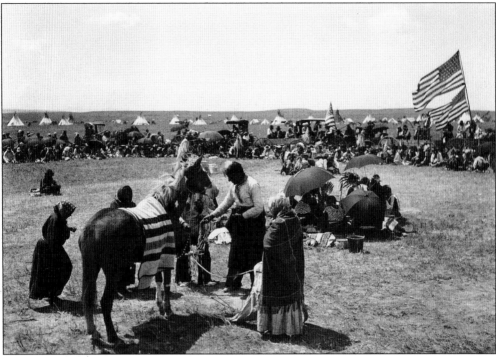

INDIANS AT A FOURTH OF JULY CELEBRATION, C. 1900. Coming from miles around, they brought food and things to give away. It was a time of festivity. (Photograph courtesy of Fort Peck Tribal Archives.)

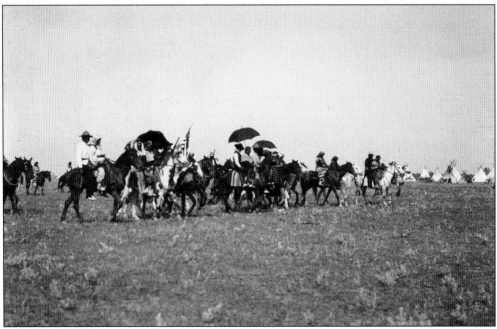

INDIANS CARRYING THE AMERICAN FLAG MAKE THEIR WAY TO THE CELEBRATION GROUNDS, C. 1900. Note the man and woman riding double on a horse. Again, the umbrellas. (Photograph courtesy of Fort Peck Tribal Archives.)

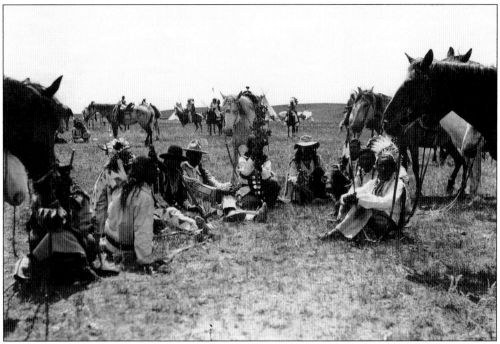

MEN GATHERING AROUND FOR SMALL TALK, C. 1900. This meeting was a time for exchanging news and making friends. (Photograph courtesy of Fort Peck Tribal Archives.)

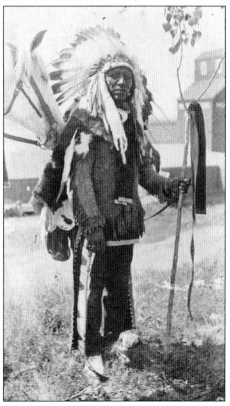

UNIDENTIFIED INDIAN MAN IN WAR BONNET, C. 1900. (Photograph courtesy of Fort Peck Tribal Archives.)

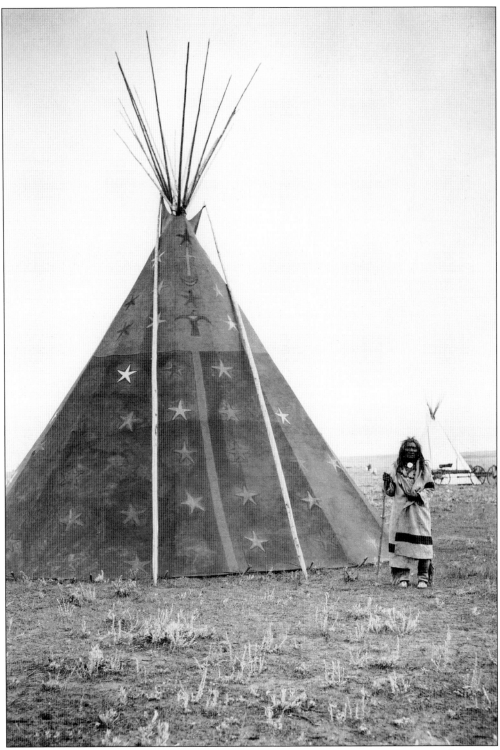

LODGE WITH CURIOUS MARKINGS TO SYMBOLIZE A CEREMONIAL TEPEE, C. 1900. The owner stands nearby. (Photograph courtesy of Fort Peck Tribal Archives.)

Five

WACHICA WAKPA
(POPLAR RIVER OR FORT PECK AGENCY)

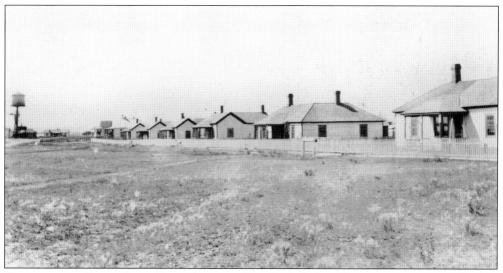

GOVERNMENT ROW, FORT PECK AGENCY. Fort Peck Indian Reservation was once known as Wahcica Wakpa or Poplar River. It has a governing body, constitution, and by-laws with an Executive Board consisting of a chairman, vice-chairman, secretary, sergeant at arms, and 12 board members. Personnel for the Fort Peck Agency were quartered at Government Row. (Photograph Courtesy of Fort Peck Tribal Archives.)

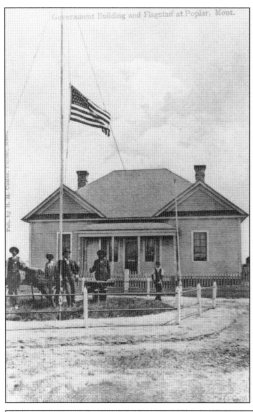

HEADQUARTERS BUILDING, FLAGSTAFF, AND CANNON, FORT PECK RESERVATION, C. 1906. The cannon was used to fire on a peaceful village in the Dakotas near the Missouri River. (Photograph courtesy of Montana Historical Society.)

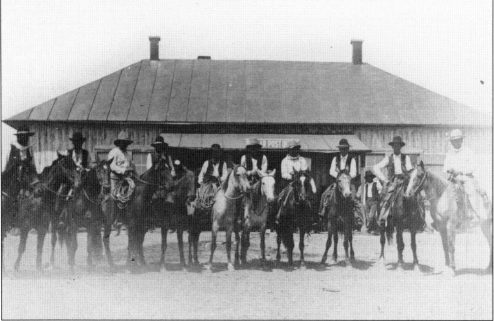

COWBOYS IN FRONT OF POPLAR POST OFFICE, C. 1906. Much range work needed to be done in surrounding areas, and Indians were sought after for their remarkable equestrian ability. (Photograph courtesy of Montana Historical Society.)

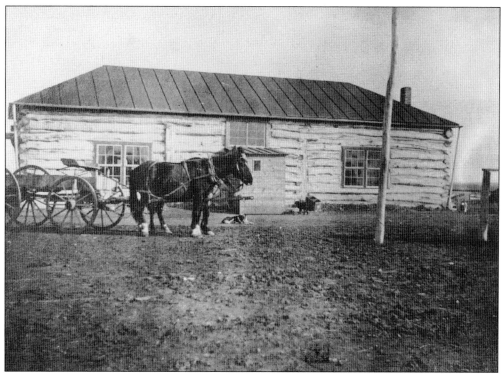

INDIAN TRADING STORE IN
WOLF POINT, MONTANA, C.
1907. Jack Colwell was the trader.
(Photograph courtesy of Montana
Historical Society.)

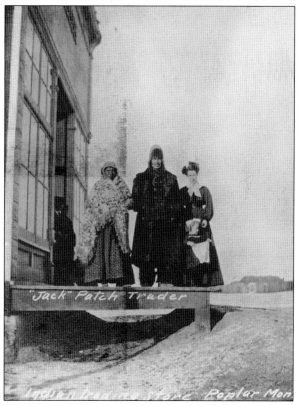

JACK PATCH, TRADER AT THE
INDIAN TRADING STORE IN
POPLAR, MONTANA, C. 1907. inters
are harsh in northeastern Montana.
(Photograph courtesy of Montana
Historical Society.)

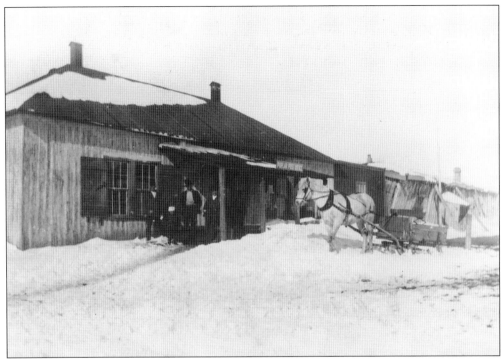

PULLING INTO THE POST OFFICE ON THE FORT PECK INDIAN RESERVATION, C. 1906. The pony express once came through this area. (Photograph courtesy of Montana Historical Society.)

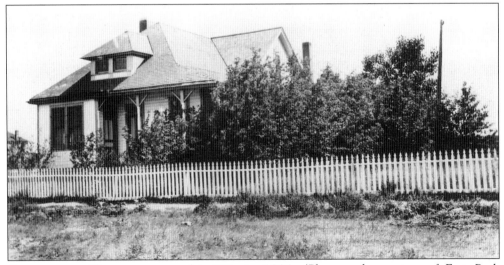

GOVERNMENT HOUSE OF THE AGENCY, C. 1904. (Photograph courtesy of Fort Peck Tribal Archives.)

MAJOR CHARLES B. LOHMILLER, SUPERINTENDENT OF THE FORT PECK AGENCY. The Indians named him "Hompazi" meaning "Yellow Shoes." (Photograph courtesy of Montana Historical Society.)

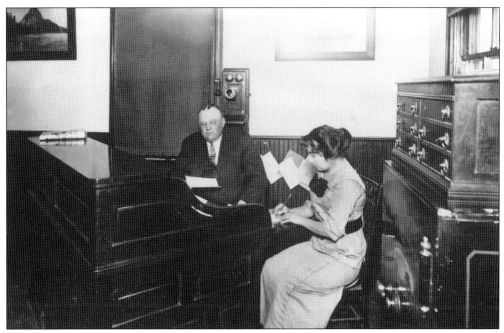

MAJOR LOHMILLER AND MISS GORDON, C. 1912. Here, Major Lohmiller dictates a letter to his young Indian secretary/stenographer. (Photograph courtesy of Montana Historical Society.)

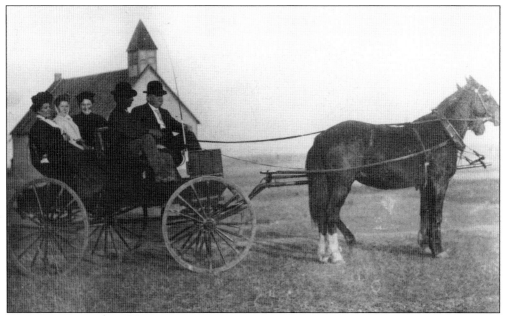

MAJOR LOHMILLER AND FAMILY ON A SUNDAY BUGGY RIDE AFTER CHURCH, C. 1910.
(Photograph courtesy of Montana Historical Society.)

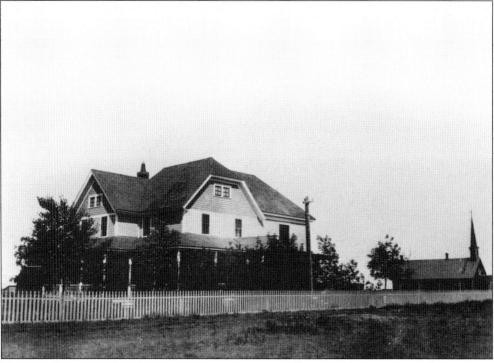

MAJOR LOHMILLER'S RESIDENCE, C. 1906. (Photograph courtesy of Montana
Historical Society.)

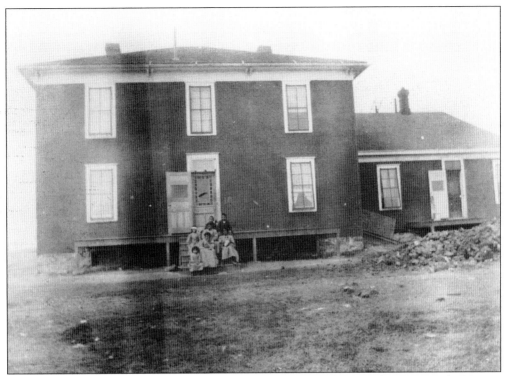

OUTSIDE A GOVERNMENT SCHOOL BUILDING, C. 1907. (Photograph courtesy of Montana Historical Society.)

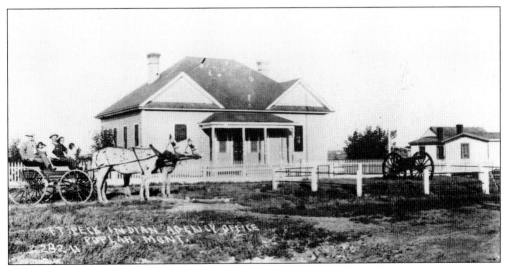

OUTSIDE FORT PECK INDIAN AGENCY HEADQUARTERS BUILDING, POPLAR, MONTANA, C. 1906. (Photograph courtesy of Montana Historical Society.)

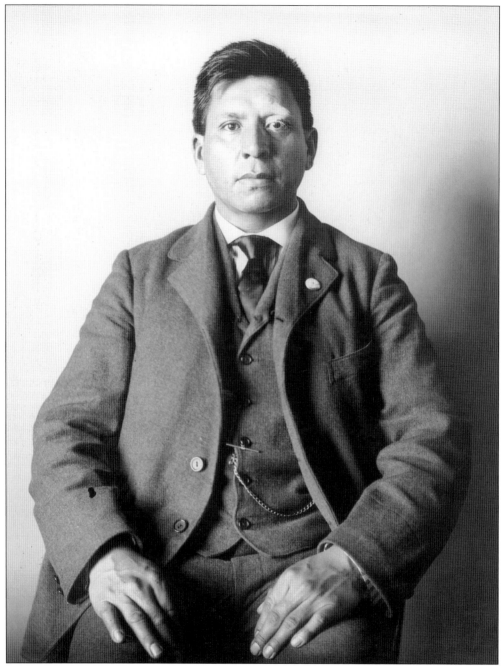

INYAN SANA—REDSTONE—ASSINIBOINE, EARLY 1900S. Born in 1874 in Wolf Point, Montana, he was called Frank Red Stone. (Photograph courtesy of Montana Historical Society.)

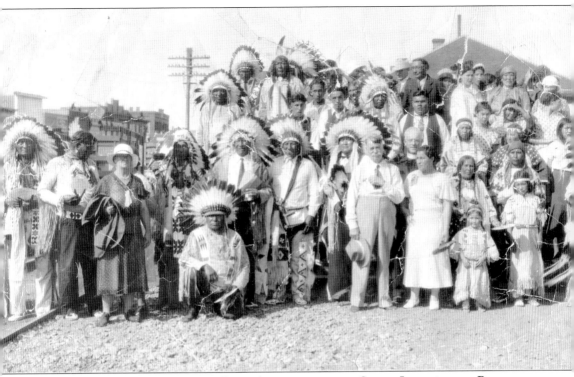

Special Delegation of Fort Peck Assiniboine and Sioux Indians for President Franklin D. Roosevelt. Pictured left to right are as follows: (front row) Ezra Ricker (kneeling), unknown, unknown, Andrew Shields, Dave Johnson, Santee Iron Ring, Joshua Wetsit, unknown, Dolly Akers, Clara Ricker, Lucile Ricker (girl), Elizabeth Lambert, unknown, and Rufus Ricker; (second row) unknown (first five), Willard Sweeney, Cynthia Johnson, and last two unknown; (third row) unknown (first eight), Basile Red Door, unknown, and Mrs. Hale. (Photograph courtesy of Fort Peck Tribal Archives.)

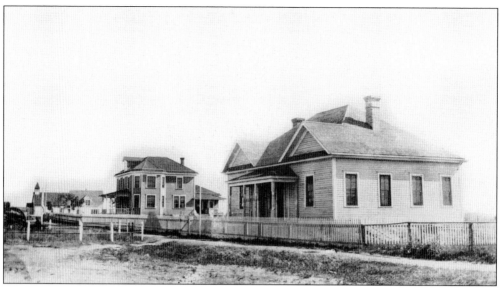

GOVERNMENT ROW LOOKING NORTH, C. 1906. The large two-story building in the middle was once used as a church. There is now a Dakota Presbyterian Church built in its place. (Photograph courtesy of Montana Historical Society.)

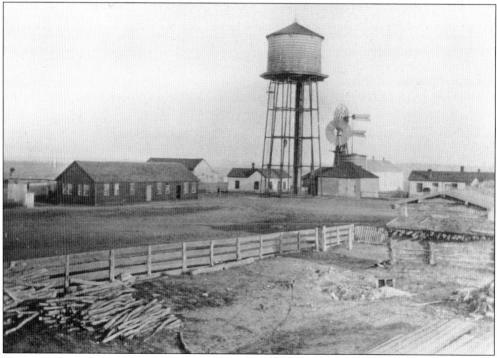

PUMPING STATION AT POPLAR, MONTANA, C. MAY 1906. Corrals were once prominent here. Indian people would come from around the reservation to receive their rations and put their horses and wagons here. (Photograph courtesy of Montana Historical Society.)

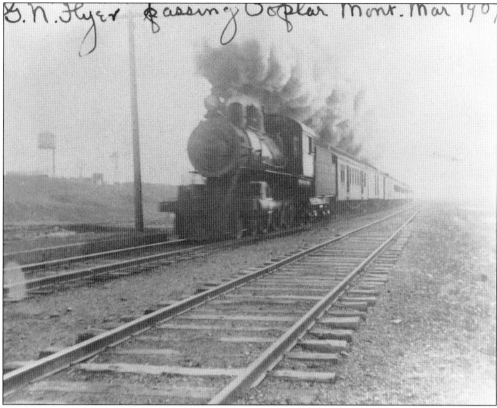

G. N. Flyer passing Poplar Mont. Mar 190_

ARRIVAL OF THE STEAM ENGINE, C. 1906. The Great Northern Railroad was finished and rail transportation afforded to Fort Peck. Many wheat farmers from this area found this a major breakthrough. Travelers enjoyed the view of the plains. (Photograph courtesy of Montana Historical Society.)

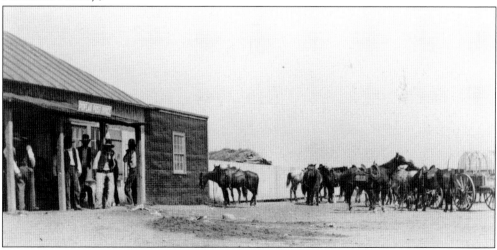

INDIAN COWBOYS CONGREGATE AROUND THE POST OFFICE, C. 1904. Gathering here meant sharing news of what was happening around the reservation. This "moccasin telegraph" was known to travel faster than modern methods of communication. (Courtesy of Montana Historical Society.)

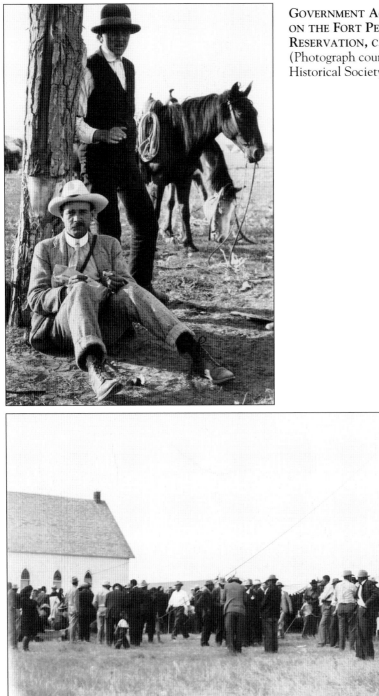

GOVERNMENT AGENTS OR SURVEYORS ON THE FORT PECK INDIAN RESERVATION, C. 1906. (Photograph courtesy of Montana Historical Society.)

FORT KIPP RED EAGLE PRESBYTERIAN CHURCH DEDICATION, 1919. Indians from the surrounding area all took part in this special event. As a very spiritual people, the Indians looked forward to better days. (Photograph courtesy of Susan Red Boy.)

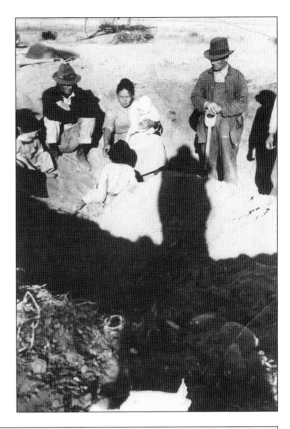

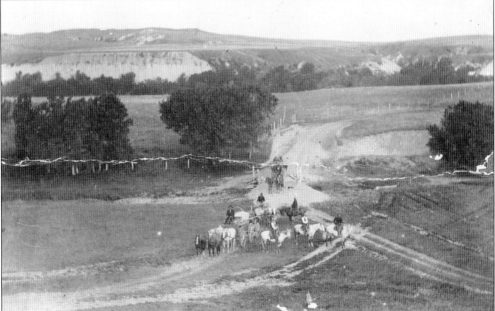

CATTLE CROSSING NORTH OF POPLAR. Many Indians enjoyed working on ranches and helping in cattle drives. Sometimes they were given horses as gratuity for their tireless labors. (Photograph courtesy of Laura Bleazard.)

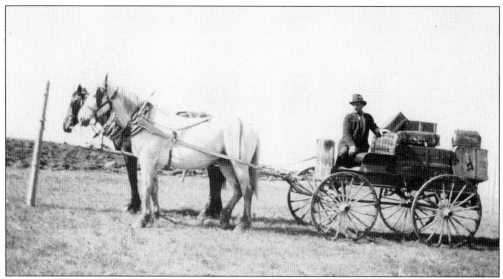

JOHN GRAINGER, 1920. In this photo, Grainger is receiving a mail order bride. (Photograph Laura Bleazard.)

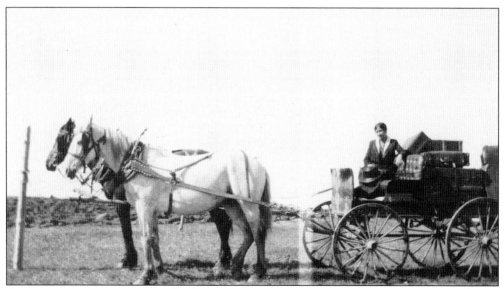

GERTRUDE GRAINGER, 1920. She departed the train at Poplar when she came as a mail order bride from Pennsylvania. These brides were not uncommon in those days. (Photograph courtesy of Laura Bleazard.)

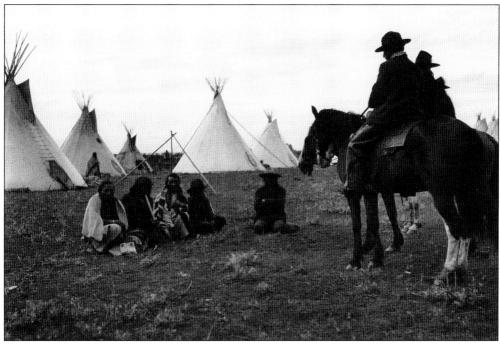

UNIDENTIFIED MEN, POSSIBLY GOVERNMENT AGENTS, AT INDIAN CAMP, C. 1904. It was sometimes a frightening moment when these men came. (Photograph courtesy of Fort Peck Tribal Archives.)

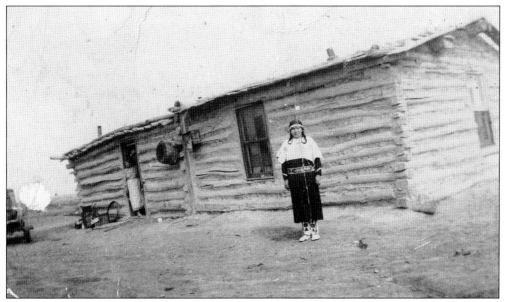

UNKNOWN INDIAN WOMAN OUTSIDE ANDREW SHIELDS'S PLACE, C. 1900. (Photograph courtesy of Susan Red Boy.)

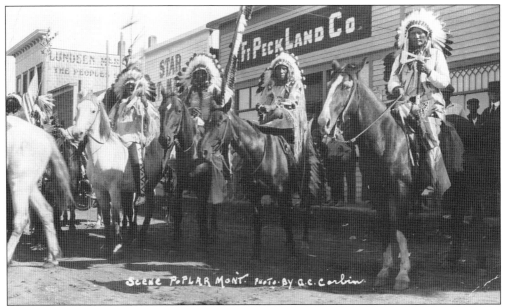

SIOUX INDIANS, JULY 1913. Here, the Indians appear dressed in all their finery on Main Street, Poplar, during the Glidden Tours. (Photograph courtesy of Montana Historical Society.)

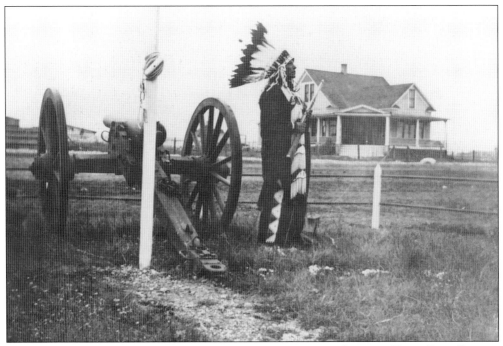

SIOUX INDIAN, KILL TWICE, POSING FOR A PHOTOGRAPHER OUTSIDE FORT PECK INDIAN AGENCY. (Photograph courtesy of Montana Historical Society.)

Six

WAYAWAPI
(BOARDING SCHOOLS)

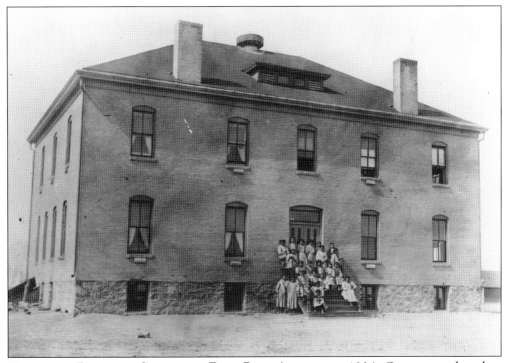

TWO-STORY BOARDING SCHOOL AT FORT PECK AGENCY, C. 1904. Government boarding schools were once commonplace, and some buildings exist to this day. While in these Wayawapi or schools, Indian students trained to farm and become homemakers. While doing farm labor/ homemaking, they called it Wowasi Econ, or working for a living. (Photograph courtesy of Montana Historical Society.)

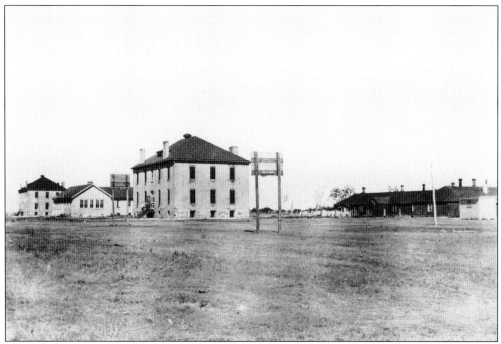

LOOKING WEST TO THE INDIAN BOARDING SCHOOL, C. 1906. The one-story building in the center was once the tribal office. Today it is known as "Old Main" for the Fort Peck Community College. (Photograph courtesy of Montana Historical Society.)

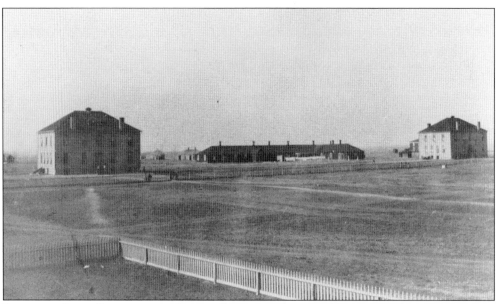

BOYS AND GIRLS DORM AT THE INDIAN BOARDING SCHOOL, FORT PECK AGENCY, C. 1904. This view was taken from the direction of one of the agency buildings. Note the picket fence. (Photograph courtesy of Montana Historical Society.)

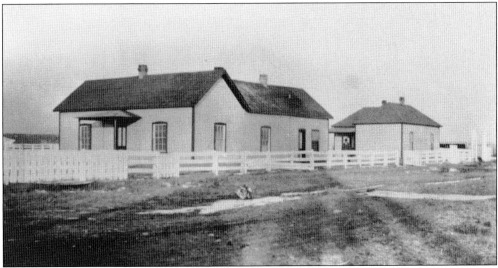

GOVERNMENT HOUSING AT WOLF POINT, MONTANA, EARLY 1900S. (Photograph courtesy of Montana Historical Society.)

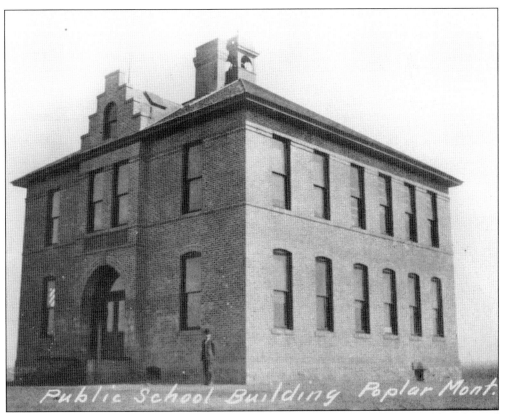

Public School Building Poplar Mont.

DORMITORY AT GOVERNMENT BOARDING SCHOOL, C. 1904. This public building housed Indian students year-round. Living quarters were very similar to the army. Note the man standing outside. (Photograph courtesy of Montana Historical Society.)

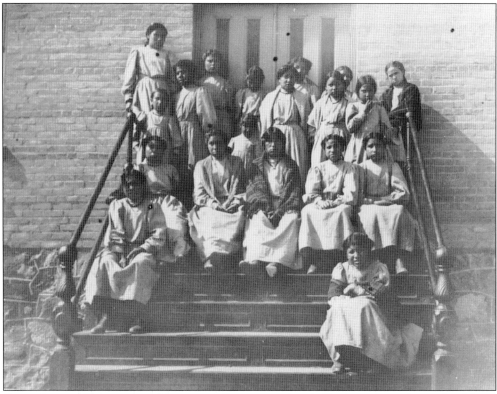

SIOUX INDIAN GIRLS AT THE BOARDING SCHOOL, C. 1906. Uniforms were the mode of dress. These girls, all of whom had Indian names before entering school, were given Christian names for government purposes once they enrolled. To speak the Indian language while in school was cause for immediate punishment. (Photograph courtesy of Montana Historical Society.)

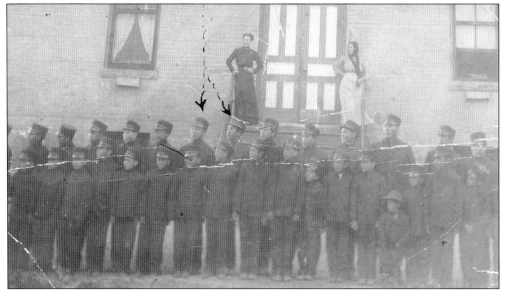

INDIAN BOARDING SCHOOL BAND, C. 1906. (Photograph courtesy of Montana Historical Society.)

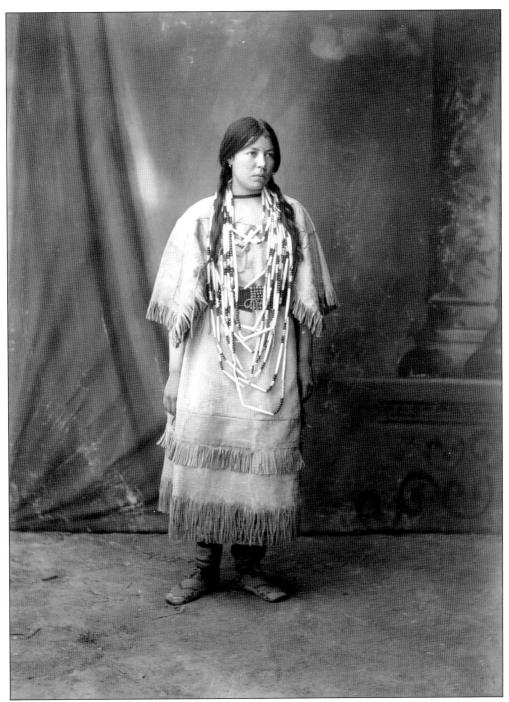

SARA MITCHELL, AGE 15, OF FORT PECK INDIAN RESERVATION, MONTANA. This picture was taken in St. Louis, Missouri, in 1904. (Photograph Courtesy of Fort Peck Tribal Archives.)

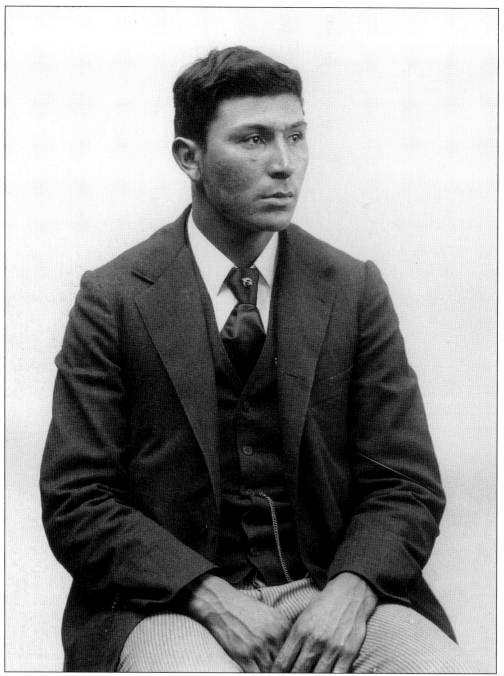

CHARLES PERRY, AGE 23, FORT PECK AGENCY, MONTANA. Perry was an Assiniboine Interpreter. (Photograph courtesy of Fort Peck Tribal Archives.)

CHILDREN AND TEACHER DURING PLAYTIME AT SCHOOL. Clair Sears is sitting in front on the bottom of the sliding board. (Photograph courtesy of Laura Bleazard.)

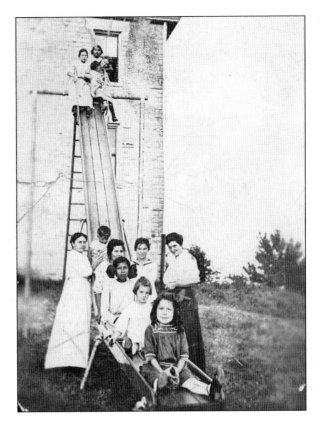

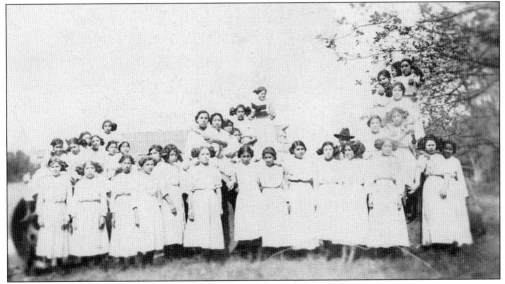

GRADUATION CLASS. (Photograph courtesy of Laura Bleazard.)

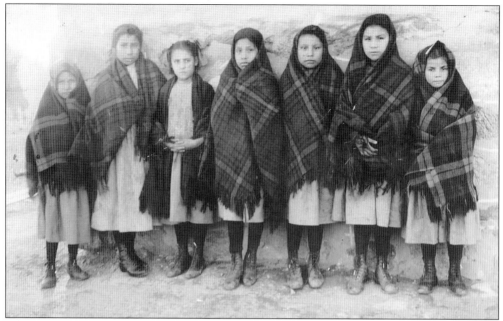

FORT PECK INDIAN GIRLS, OCTOBER 14, 1911. Pictured from left to right are as follows: Nellie Brugier, Mary Eagleman, Mary Turning Pine, Minnie Red Boy, Lizzie Keiser, Elise Kills Thunder, and Ella Red Boy.

BELVA KENNEDY AND BESSIE BENEDICT, EARLY 1900s. (Photograph courtesy of Susan Red Boy.)

SCHOOL PORTRAIT OF UNIDENTIFIED INDIAN GIRL. (Photograph courtesy of Fort Peck Tribal Archives.)

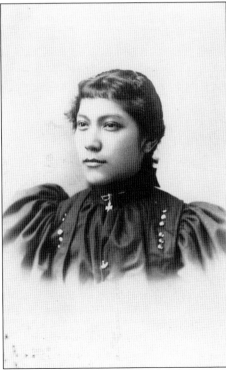

UNIDENTIFIED YOUNG INDIAN WOMAN. (Photograph courtesy of Fort Peck Tribal Archives.)

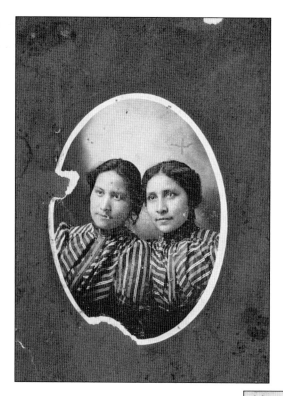

LAURA S. EAGLE AND SUZY BAKER RYAN AT CARLISLE INDIAN SCHOOL, PENNSYLVANIA, EARLY 1900s. They stayed there many years before returning to the Fort Peck Indian Reservation. Suzy was taken from her home at eight years of age. (Photograph courtesy of Susan Red Boy.)

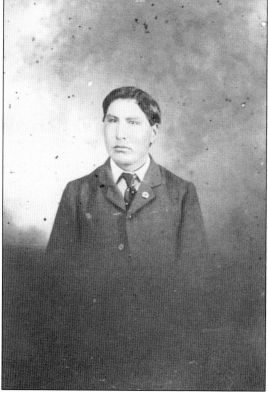

PORTRAIT OF A YOUNG INDIAN MAN. (Photograph courtesy of Fort Peck Tribal Archives.)

Seven

WOWASI ECON
(WORK FOR A LIVING)

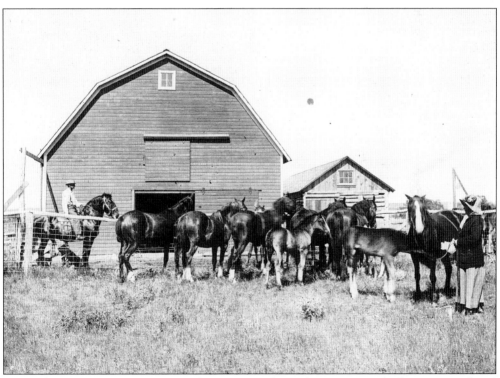

RANCH/FARM LOCATED NORTH OF POPLAR. People on the reservation had many agricultural jobs. (Photograph courtesy of Fort Peck Tribal Archives.)

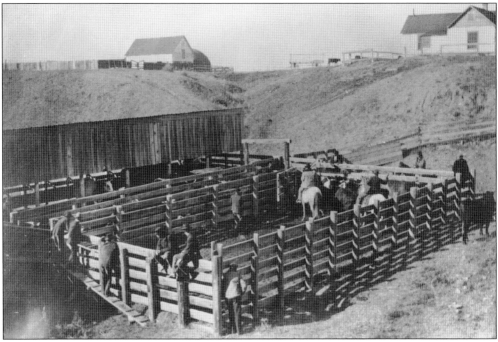

CORRAL WITH INDIAN COWBOYS, LOCATED SOUTH OF POPLAR AT THE GREAT NORTHERN RAILYARD, C. 1904. Livestock was penned here for shipment to market. (Photograph courtesy of Montana Historical Society.)

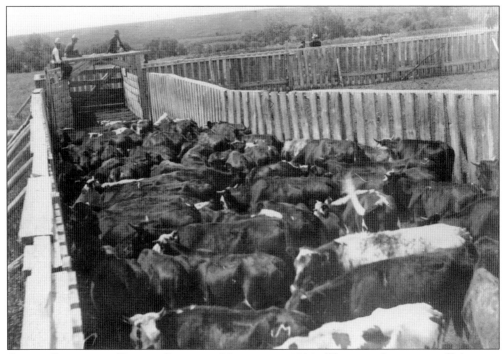

CATTLE INSPECTION BEFORE GOING TO MARKET, C. 1904. (Photograph courtesy of Montana Historical Society.)

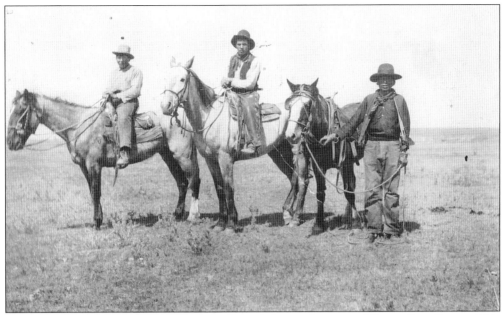

FORT PECK INDIANS, DATE UNKNOWN. From left to right are as follows: Sam Savior, Eddy Bear, and Otto Browning. (Photograph courtesy of Fort Peck Tribal Archives.)

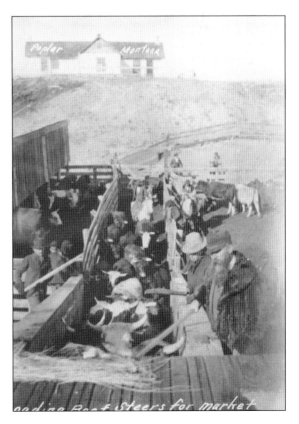

LOADING BEEF STEERS FOR MARKET, c. 1904. (Photograph courtesy of Montana Historical Society.)

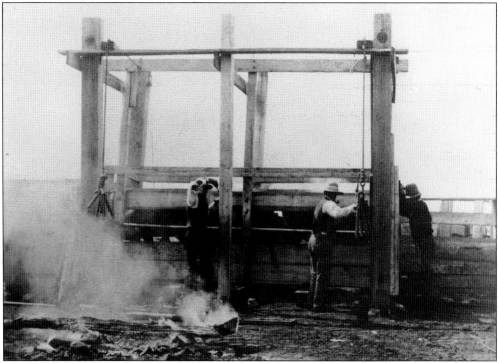

INSPECTION OF COWS BEFORE LOADING TO MARKET. (Photograph courtesy of Laura Bleazard.)

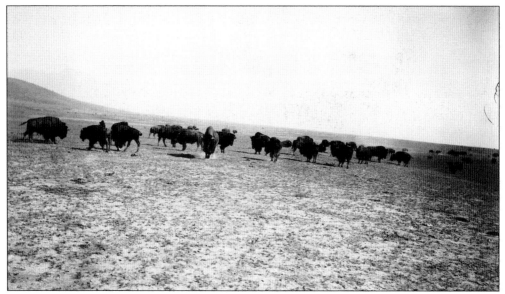

NORTH AMERICAN BISON IN THEIR HABITAT, C. 1890. Buffalo still roam today but not in the millions as they once had. Now the Fort Peck Tribes hope to raise them at some future time. (Photograph courtesy of Laura Bleazard.)

CALF, NURSED BACK TO HEALTH BEFORE BEING RETURNED TO THE HERD, C. 1913. These buildings are located at Poplar Agency. Note the Catholic church in the background. (Photograph courtesy of Laura Bleazard.)

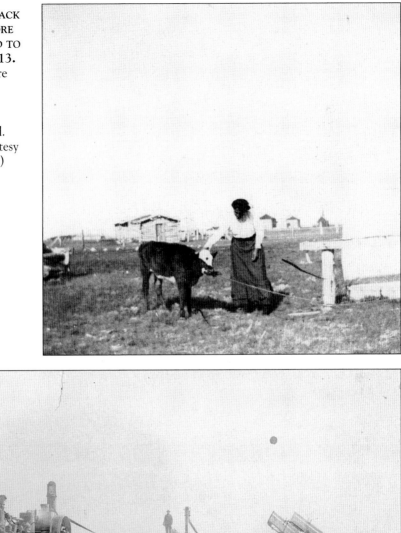

BOB, BILL, AND JOHN GRAINGER, 1916. These men appear with their threshing crew, which consisted of all young Indian men from Fort Peck Agency. Note the old steam engine. (Photograph courtesy of Laura Bleazard.)

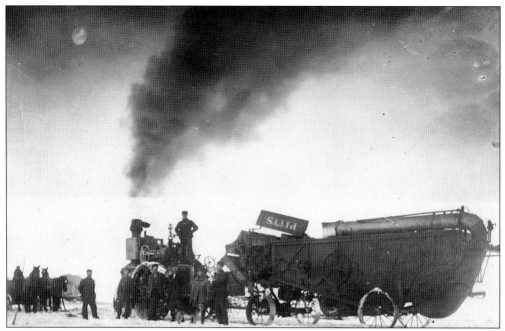

THRESHING CREW, C. 1920. Bob, Earl, Grainger, and George Newberry operate a steam engine. The man on the tractor is unidentified. (Photograph courtesy of Laura Bleazard.)

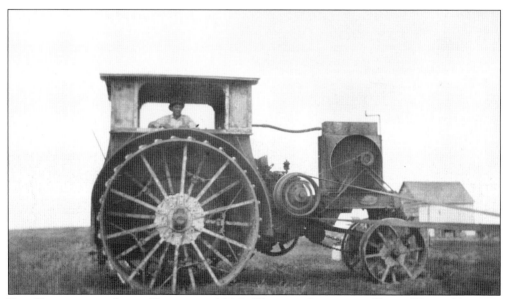

BOB GRAINGER ON STEAM ENGINE, C. 1916. (Photograph courtesy of Laura Bleazard.)

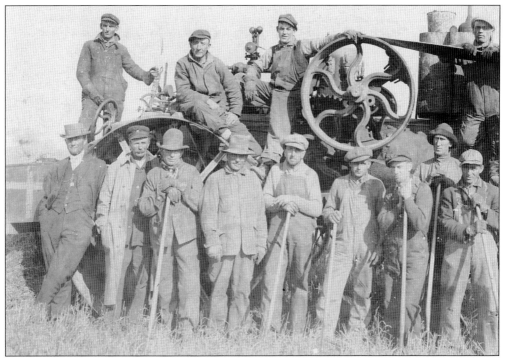

JOHN AND BILL GRAINGER WITH STEAM ENGINE AND THRESHING CREW, C. 1914. The men, all local, were working north of Poplar on the Fort Peck Indian Reservation. (Photograph courtesy of Laura Bleazard.)

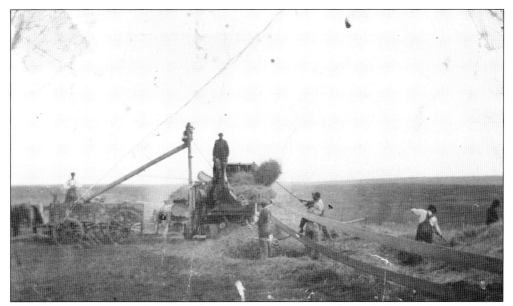

BOB GRAINGER WITH INDIAN THRESHING CREW, C. 1916. (Photograph courtesy of Laura Bleazard.)

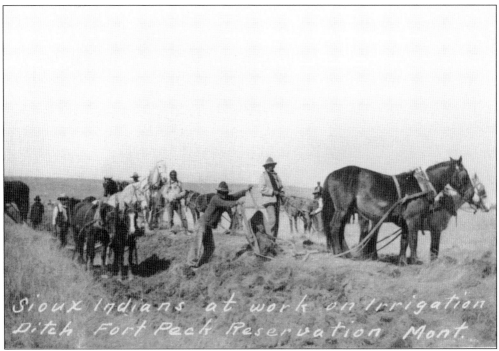

SIOUX INDIANS AT WORK ON IRRIGATION DITCH, C. 1900. This photograph was taken at the Fort Peck Indian Reservation. (Photograph courtesy of Fort Peck Tribal Archives.)

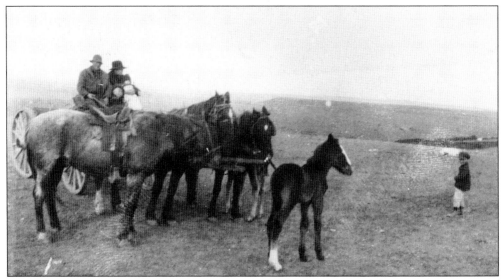

BOB AND JOSEPHINE GRAINGER IN THE OLD DAYS, C. 1919. (Photograph courtesy of Laura Bleazard.)

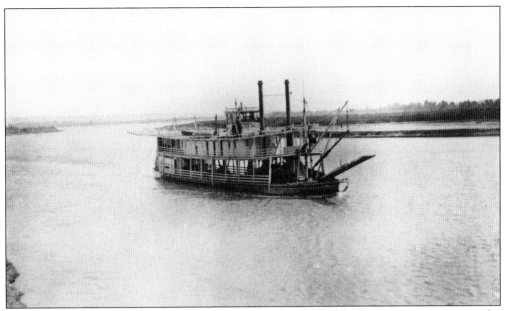

THE STEAMBOAT, OK, ON THE MISSOURI RIVER, C. 1905. The boat was on its way up the river from Williston, North Dakota. Sightings of these steamboats were much looked forward to because they served as a link to the outside world, carrying passengers and mail from the east. The Indians would chop wood to sell to the river captain to fuel the steamboat. Some of these vessels now lie at the bottom of the Missouri River. (Photograph courtesy of Montana Historical Society.)

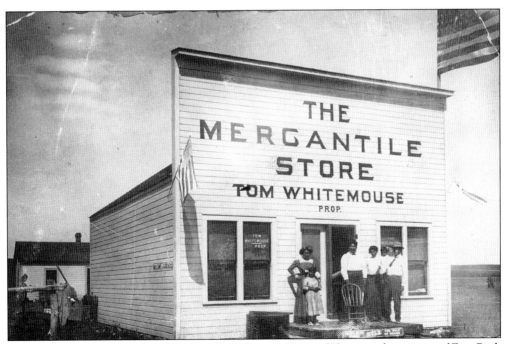

MERCANTILE STORE OF TOM WHITEMOUSE, EARLY 1900S. (Photograph courtesy of Fort Peck Tribal Archives.)

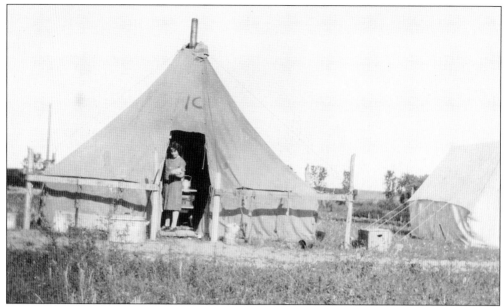

WORLD WAR I ISSUE COOK TENT NEAR POPLAR RIVER, C. 1918. Bob and Josephine Grainger used this mobile kitchen to feed the threshing crew. (Photograph courtesy of Laura Bleazard.)

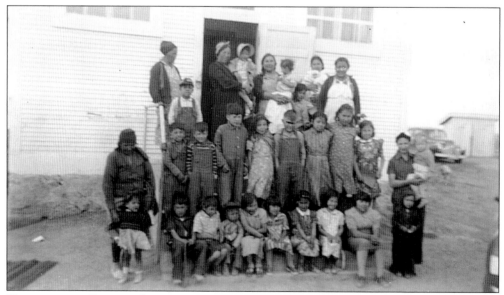

UNIDENTIFIED INDIAN SCHOOLCHILDREN AT THE RIVERSIDE DAY SCHOOL, C. 1930. (Photograph courtesy of Fort Peck Tribal Archives.)

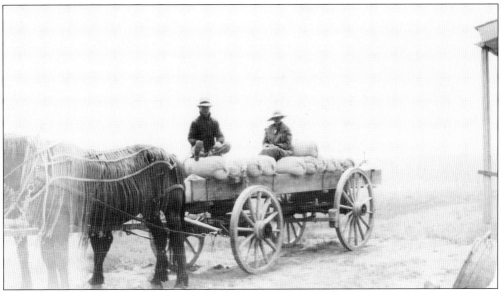

HAULING ESSENTIALS IN A GRAIN WAGON NORTH OF POPLAR, C. 1918. The people remain unidentified. (Photograph courtesy of Laura Bleazard.)

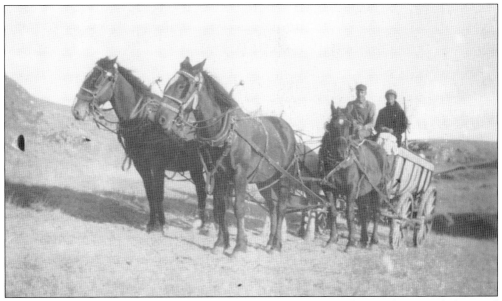

PAULA HAYNE AND EARL GRAINGER, C. 1919. Women were stalwart, taking much farm and ranch responsibility to themselves. (Photograph courtesy of Laura Bleazard.)

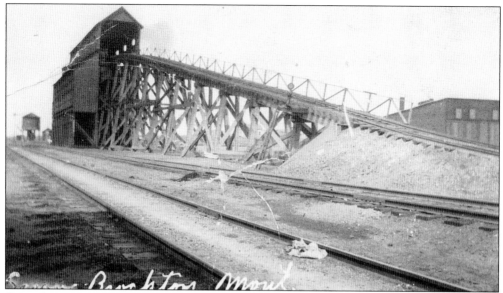

COAL CHUTE AT BROCKTON, MONTANA, C. 1907. The coal vein near here has never yielded to its potential. Steam-powered engines needing this type of fuel gave way to a new generation of locomotives—the diesel. (Photograph courtesy of Montana Historical Society.)

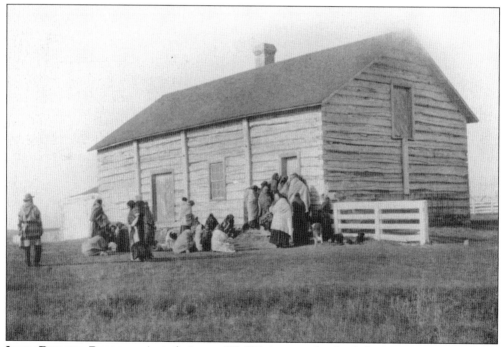

ISSUE DAY FOR RATIONS. Assiniboines at Wolf Point wait for the disbursing agent to arrive.

Eight

AOKASIN
(A LOOK INTO THEIR LIVES)

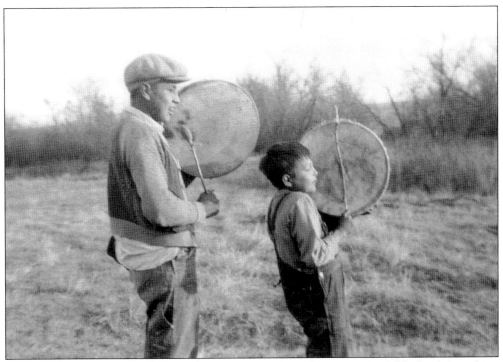

UNIDENTIFIED INDIAN MAN AND BOY, C. 1918. The father was responsible for the teaching of the son. Here they both take part in Odowan, a song. (Photograph courtesy of Fort Peck Tribal Archives.)

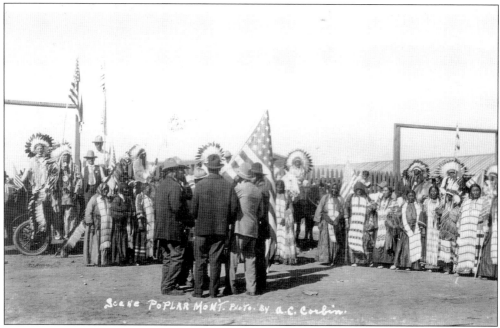

CELEBRATING AT POPLAR, MONTANA, C. 1918. Indian women gather around in support of the men. To hold the American flag was a great honor. It meant that this land was fought and died for in blood. (Photograph courtesy of A.C. Corbin.)

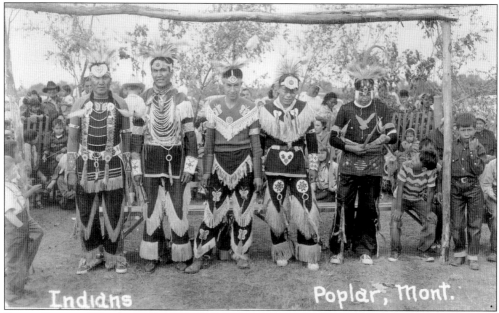

SIOUX INDIAN "GRASS DANCERS" AT POPLAR, MONTANA. Pictured from left to right are as follows: Jim Red Fox, Gerald Red Elk, David DeMarrias, Kenneth Shields Sr., and Angus Myrick. Grass dances are smooth and swift performances. (Photograph courtesy of Fort Peck Tribal Archives.)

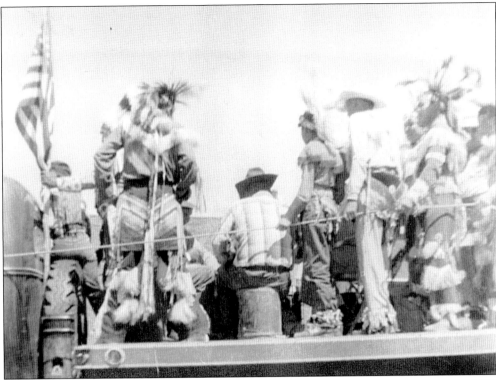

**GRASS AND TRADITIONAL DANCERS
PERFORMING IN A PARADE.** Indian men
lean into their drum and sing a song called,
"Belting One Out," in Indian powwow
circles. (Photograph courtesy of Fort Peck
Tribal Archives.)

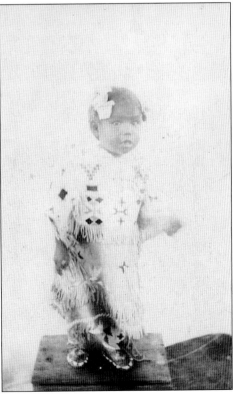

UNKNOWN INDIAN GIRL. (Photograph
courtesy of Fort Peck Tribal Archives.)

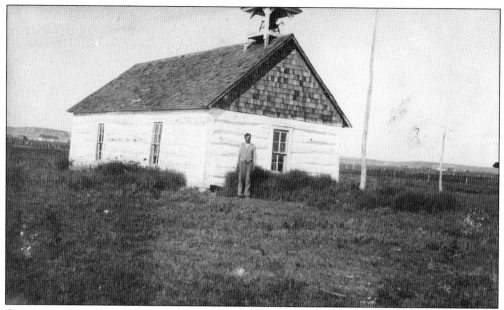

CATHOLIC CHURCH, FORT PECK AGENCY, C. 1900S. (Photograph courtesy of Fort Peck Tribal Archives.)

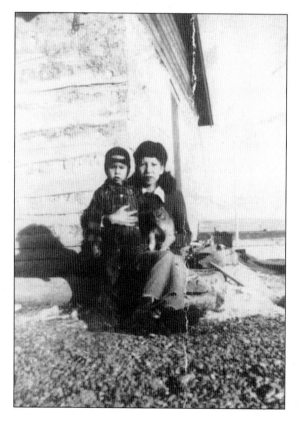

SIOUX INDIAN MERCY WHITE BEAR AND OLDEST SON MIKE THOMAS AT FORT KIPP, MONTANA. (Photograph courtesy of Mercy White Thunder White Bear.)

MELDA FIRE MOON AND NORMA FOUR STAR.
(Photograph courtesy of Darlene Grey.)

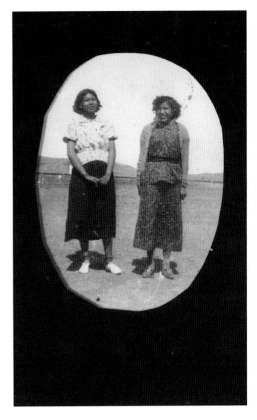

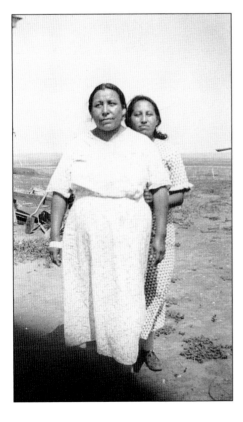

EDNA FALL AND NIECE FROM FORT PECK INDIAN RESERVATION. (Photograph courtesy of Laura Bleazard.)

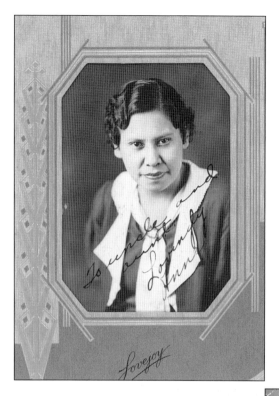

YOUNG ANNE HANCOCK. (Photograph courtesy of Anne Hancock.)

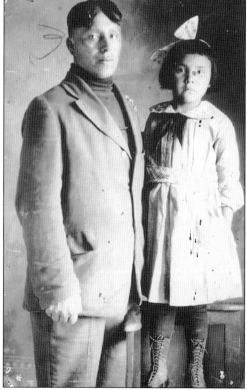

FRANK SEARS AND DAUGHTER CLAIR, EARLY 1900S. (Photograph courtesy of Laura Bleazard.)

CLAIR SEARS OF POPLAR, MONTANA.
(Photograph courtesy of Fort Peck
Tribal Archives.)

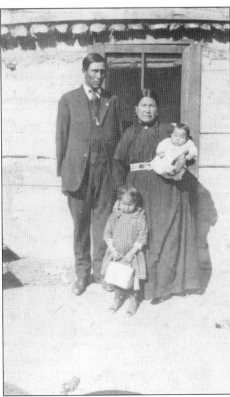

**UNKNOWN INDIAN FAMILY, FORT PECK
INDIAN AGENCY.** (Photograph courtesy of Fort
Peck Tribal Archives.)

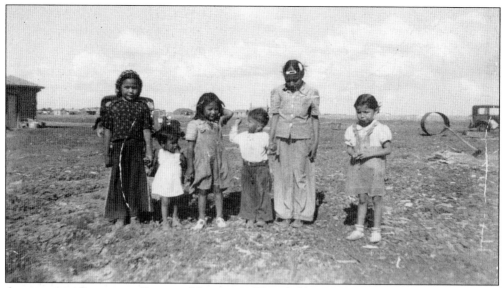

ASSINIBOINE CHILDREN, FRAZER, MONTANA. The children are from left to right as follows: unknown, Judy Fire Moon Shields, Darlene Four Star Grey, Melvin Fire Moon, and (last two) unknown. The location was a place known as Fire Moon Hill. (Photograph courtesy of Darlene Grey.)

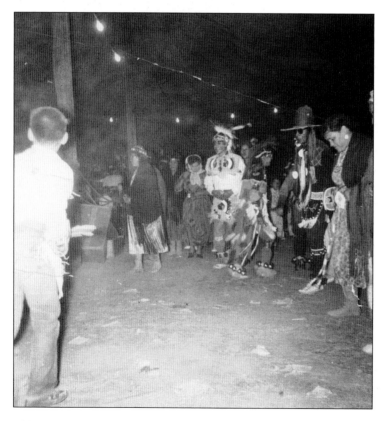

INDIAN DANCERS AT A CELEBRATION, OR POWWOW, C. 1920. (Photograph courtesy of Fort Peck Tribal Archives.)

PORTRAIT OF AN INDIAN COUPLE. (Photograph courtesy of Fort Peck Tribal Archives.)

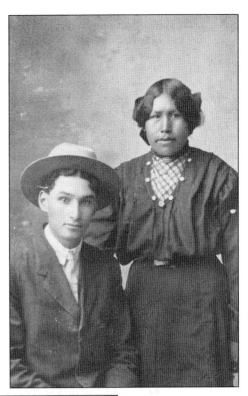

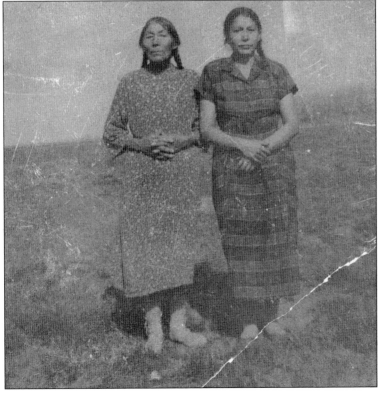

MOTHER AND SISTER ON FORT PECK INDIAN RESERVATION, C. 1900. (Photograph courtesy of Fort Peck Tribal Archives.)

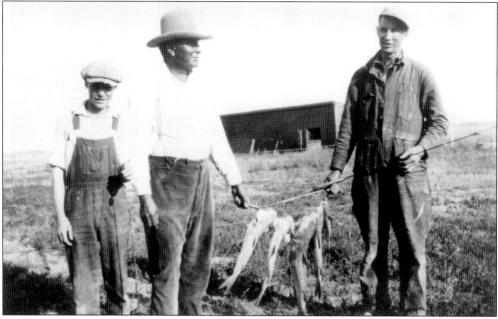

A Day's Catch at the Poplar River, c. 1920. Pictured here are Tom Ryan Sr., unknown, Joe Klinkhammer (?). (Photograph courtesy Fort Peck Tribal Archives.)

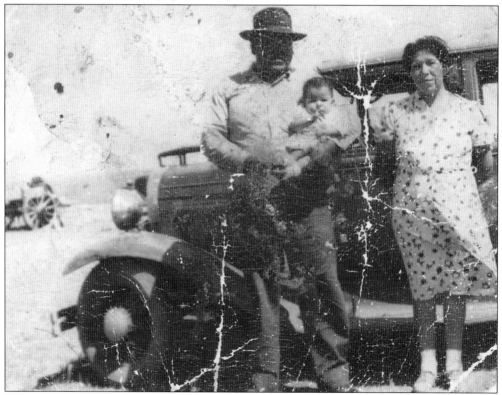

Andrew and Gay Four Star Holding Baby Shirley Four Star Gleed. (Photograph courtesy of Darlene Grey.)

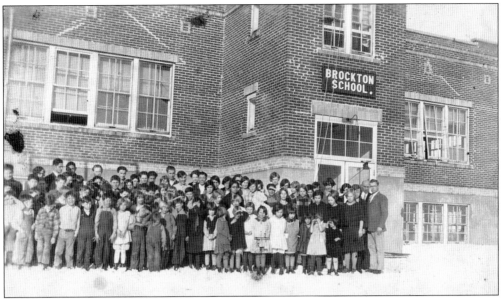

INDIAN SCHOOLCHILDREN OUTSIDE THE NEW BROCKTON SCHOOL. A big change came over these people from the days of government boarding school. Now they can go home in the evening. (Photograph courtesy of Fort Peck Tribal Archives.)

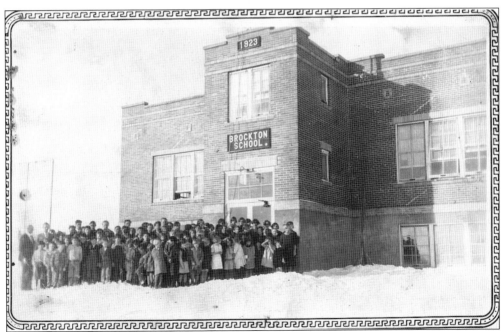

THE BROCKTON SCHOOL WITH INDIAN CHILDREN ON THE WAY TO CLASS. (Photograph courtesy of Fort Peck Tribal Archives.)

CHICKEN HILL DANCE HALL, A POPULAR COMMUNITY HALL. (Photograph courtesy of Fort Peck Tribal Archives.)

SIOUX INDIAN HERMAN WHITE THUNDER AT FORT KIPP, MONTANA, FORT PECK INDIAN RESERVATION. (Photograph courtesy of Mercy White Thunder White Bear.)

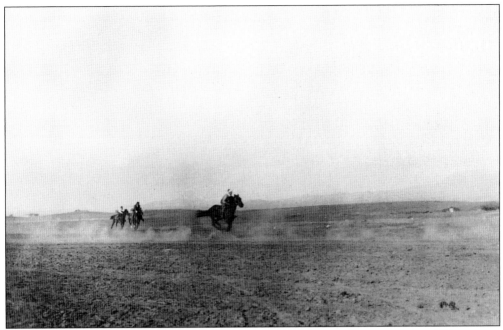

HORSE RACING, A FAVORITE SPORT ON THE FORT PECK INDIAN RESERVATION. Almost every family owned a horse; most Indians were very fond of them. Here, they race across the prairie. (Photograph courtesy of Montana Historical Society.)

MARVA AND KATHY RUNS THROUGH. (Photograph courtesy of Darlene Grey.)

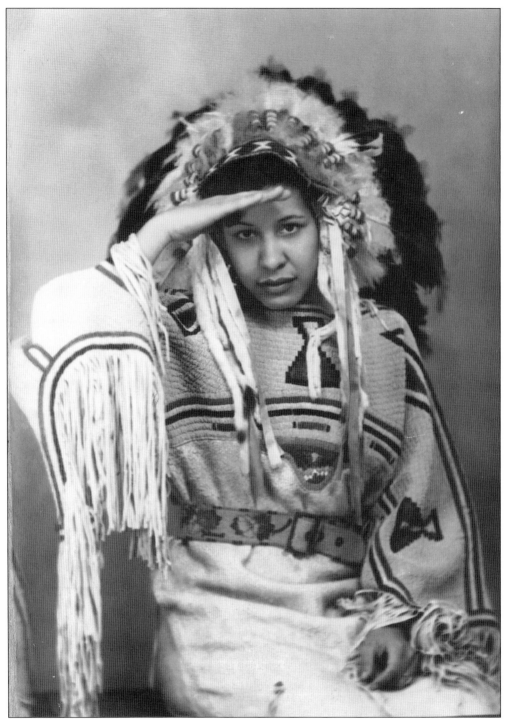

AN ASSINIBOINE LADY DRESSED IN FINE BUCKSKIN. This lady is Wilma Yellowrobe Williamson from Wolf Point, Montana. (Photograph courtesy of Wilma Yellowrobe Williamson.)

Nine

IKITURA
(A DELIGHTFUL PEOPLE)

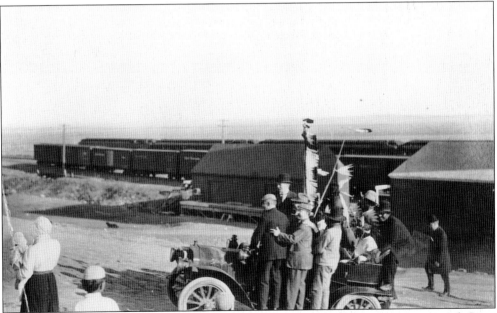

POPLAR TRAIN DEPOT, JULY 13, 1917. People went to the depot to meet a special Great Northern train commemorating the Glidden Tours. Government dignitaries and Fort Peck Indian leaders jumped on the bandwagon, a Model T, and made their way to celebrate at uptown Poplar, Montana. Note the dog running in terror in the background. (Photograph courtesy of Montana Historical Society.)

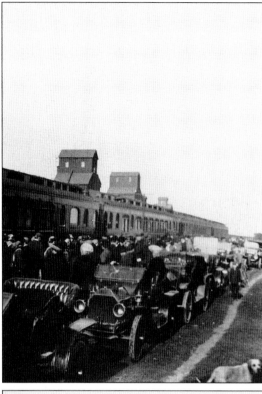

POPLAR DEPOT, 1917. Tour cars lined up to take on important officials. The Great Northern Railroad proved to be a great asset for surrounding farms and ranches, not to mention first-class transportation. (Photograph courtesy of Montana Historical Society.)

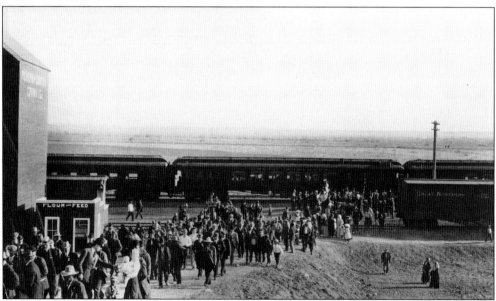

EXITING THE TRAIN AND STATION, C. 1917. As people leave the train and depart the station they are met by welcomers of the Fort Peck Indian Agency. At the top of the hill was a splendid hotel for that era. The Gateway Hotel provided maid service, butlers, beautiful carpet, fine dining, and even an elevator called a "lazy waiter" to transport meals from the basement to the kitchen. It was the largest and highest structure at that time and still stands today. (Photograph courtesy of Montana Historical Society.)

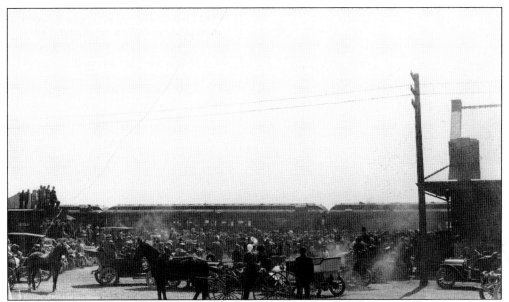

ANOTHER VIEW OF PEOPLE DEPARTING THE GREAT NORTHERN PASSENGER TRAIN. (Photograph courtesy of Montana Historical Society.)

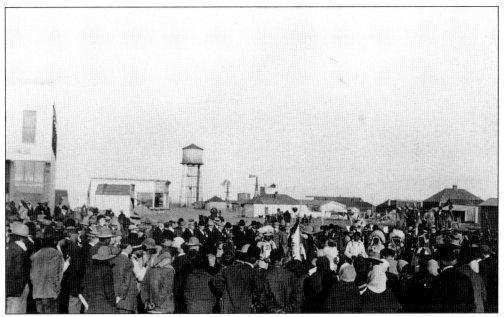

MAIN STREET, POPLAR, C. 1917. Delegates and important Indian leaders gather in here to begin the festivities celebrating the Glidden Tours and the special Great Northern Train. (Photograph courtesy of Montana Historical Society.)

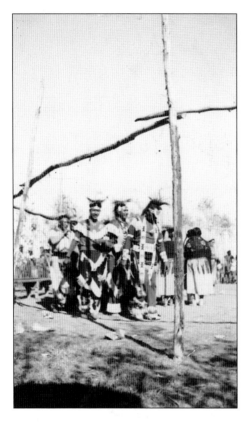

GRASS DANCERS, EARLY DAY POWWOW, FORT PECK INDIAN AGENCY. Pictured at left is David DeMarrias and in the center are Gerald Red Elk and an unknown man. (Photograph courtesy of Fort Peck Tribal Archives.)

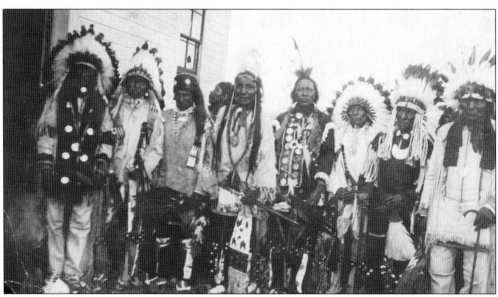

LEADERSHIP OF FORT PECK INDIAN RESERVATION. (Photograph courtesy of Fort Peck Tribal Archives.)

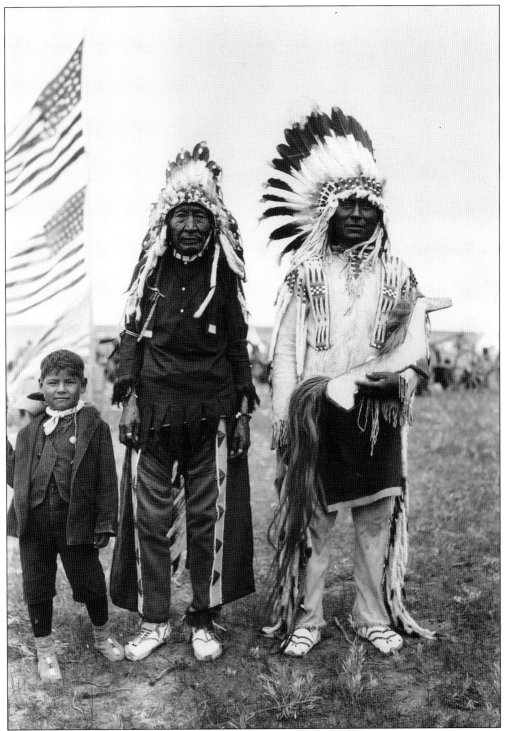

UNIDENTIFIED INDIAN PARTICIPANTS IN A FOURTH OF JULY CELEBRATION. (Photograph courtesy of Fort Peck Tribal Archives.)

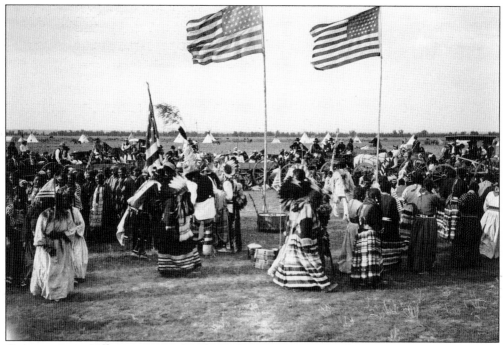

CELEBRATION, EARLY 1900S. Amid much singing and dancing, the American Indians celebrate the Independence Day of the United States. (Photograph courtesy of the Fort Peck Tribal Archives.)

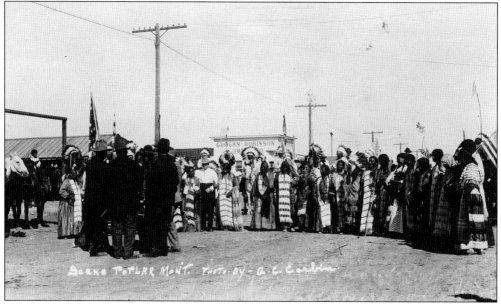

INDIAN FESTIVITIES BEGIN, 1917. Sioux Indians gathered in the streets of Poplar listening and dancing to songs. Later, some gave speeches. (Photograph courtesy of Montana Historical Society.)

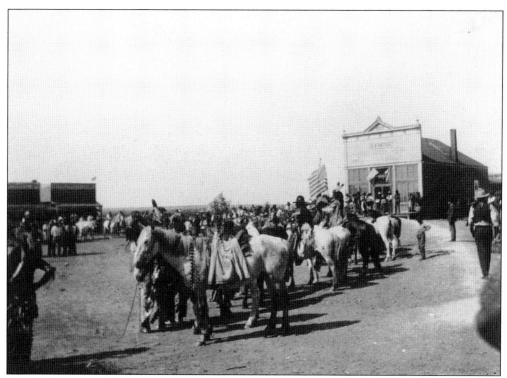

POPLAR, C. 1917. People and horses line the streets to celebrate and remember a good day. Note the old merchant business in the background. (Photograph courtesy of Montana Historical Society.)

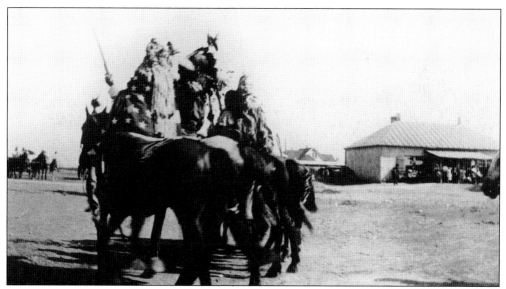

AN EARLY PARADE, C. 1917. (Photograph courtesy of Montana Historical Society.)

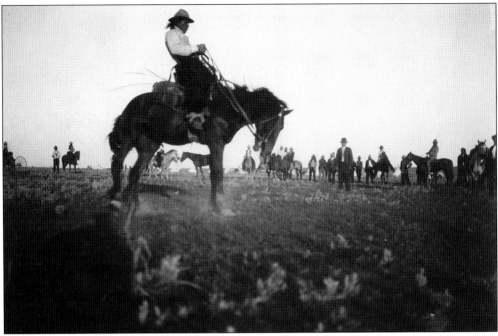

RODEO, C. 1917. More often than not, the Indian cowboys of Fort Peck Reservation show their stuff. Holding tight, this bronco rider stays on for the count. Rodeos are still a favorite pastime. (Photograph courtesy of Fort Peck Tribal Archives.)

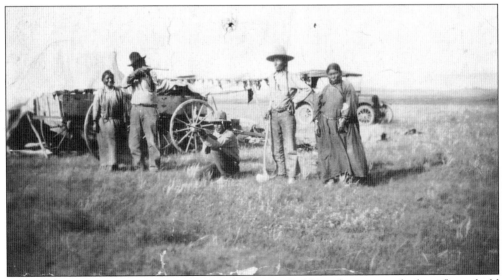

FAMILY CAMPING OUT AND DRYING MEAT, C. 1919. Note the man with the rifle and old Model T car in the background. (Photograph courtesy of Montana Historical Society.)

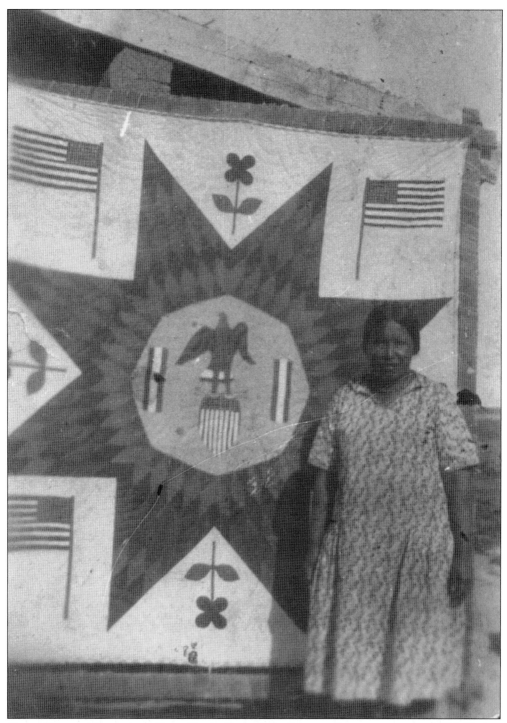

SIOUX WOMAN ELIZABETH GREY BULL, FORT PECK INDIAN RESERVATION, C. 1920. Sitting outside her log home in Blair, Montana, she displays a star quilt she sewed by hand that won first place at the Presbyterian Mission meeting in Messiah, South Dakota. (Photograph courtesy of Nellie Silk.)

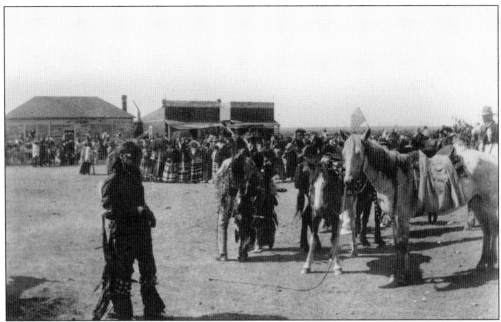

FESTIVITIES ON MAIN STREET IN POPLAR, FORT PECK AGENCY, C. 1917. (Photograph courtesy Montana Historical Society.)

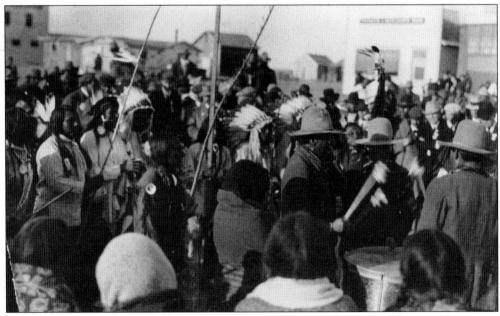

MUSICAL CELEBRATION. Indians gather around the drum to make music. (Photograph courtesy of Fort Peck Tribal Archives.)

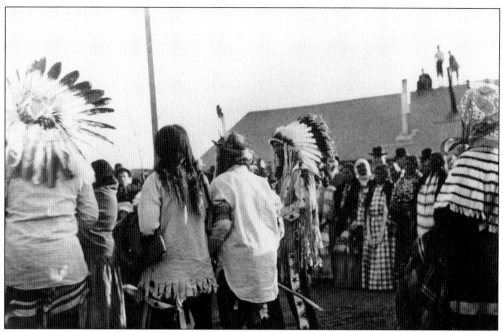

SIOUX LEADER AND HIS PEOPLE, 1917. In this photograph, the leader joins with his people in celebrating a special day. (Photograph courtesy of Montana Historical Society.)

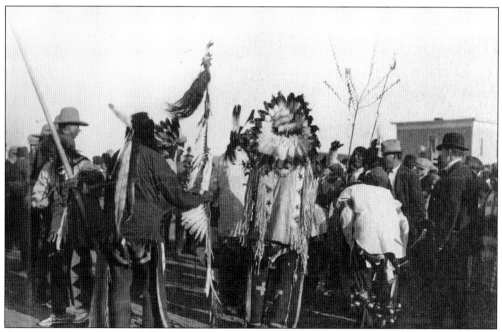

DANCING MEN, C. 1917. One of the dignitaries watches as the men dance in a circle while others wait to join in. He will later be asked to dance along with them. (Photograph courtesy of Montana Historical Society.)

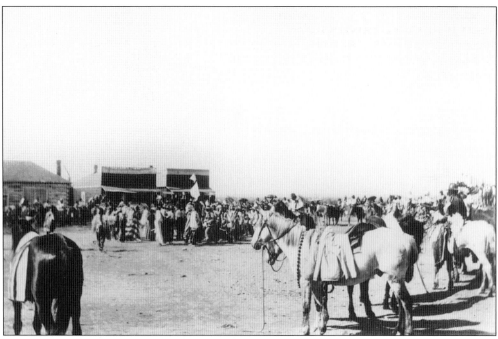

A WIDE VIEW OF PEOPLE AND THE CELEBRATION, C. 1917. These festivals go on for many hours. (Photograph courtesy of Montana Historical Society.)

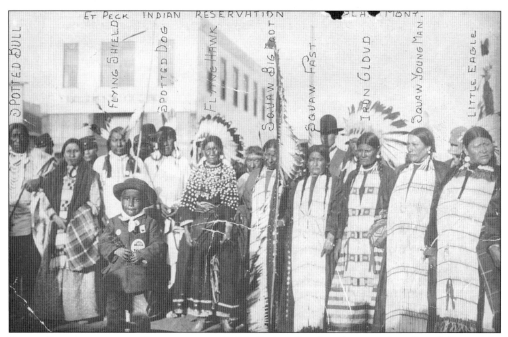

SIOUX INDIANS AT THE FESTIVITY, C. 1917. Posing for the photographer from left to right are as follows: Spotted Bull, two unidentified, Flying Shield, Spotted Dog, Flying Hawk, unidentified, Bigfoot, Fast, unidentified white man, unidentified Indian in war bonnet, Iron Cloud, Youngman, and Little Eagle. The Indian boy in front is unidentified. (Photograph courtesy of Montana Historical Society.)

MARIE CANTRELL AT THE RALPH JONES FEAST IN RIVERSIDE, MONTANA. Note the intricate quill work embracing the shoulders. (Photograph courtesy of Marie Cantrell.)

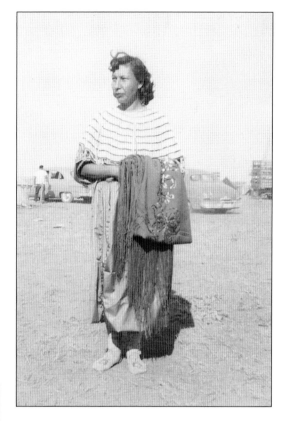

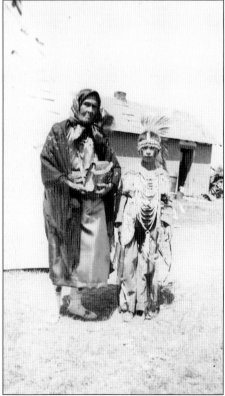

YOUNG DANCER AND HIS ELDER, FORT PECK RESERVATION. (Photograph courtesy of Fort Peck Tribal Archives.)

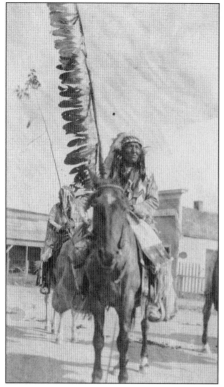

SIOUX LEADER, C. 1917. The eagle staff he carries represents a noble people. (Photograph courtesy of Montana Historical Society.)

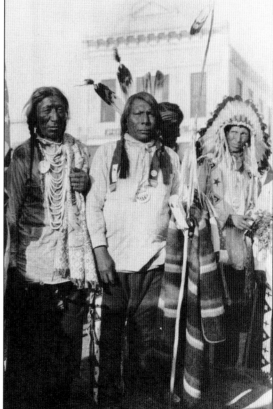

SIOUX MEN. Pictured are as follows: Spotted Bull, Flying Shield, and an unidentified Indian. This photograph was taken at the conclusion of the Glidden Tours. (Photograph courtesy of Montana Historical Society.)

Hecetu. (That is how it is.)